EDVARD MUNCH

ØYSTEIN USTVEDT

EDVARD MUNCH
AN INNER LIFE

TRANSLATED FROM THE NORWEGIAN
BY ALISON MCCULLOUGH

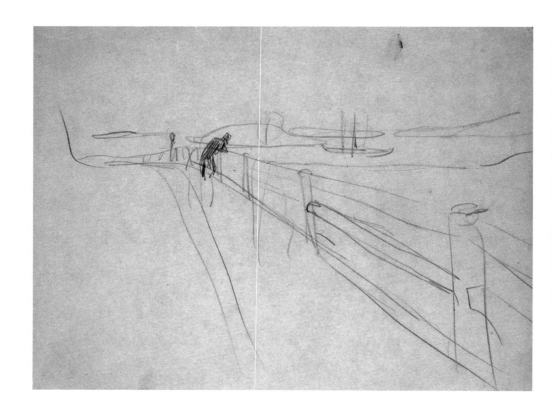

Ljabru Chaussee. Man leaning against a railing, 1891, pencil on paper, 23.1 × 30.8 cm.

My art is a self-confession – in it I seek to clarify my relationship with the world. But at the same time I have always thought and felt that my art could also clarify other people's quest for the truth.

Edvard Munch

CONTENTS

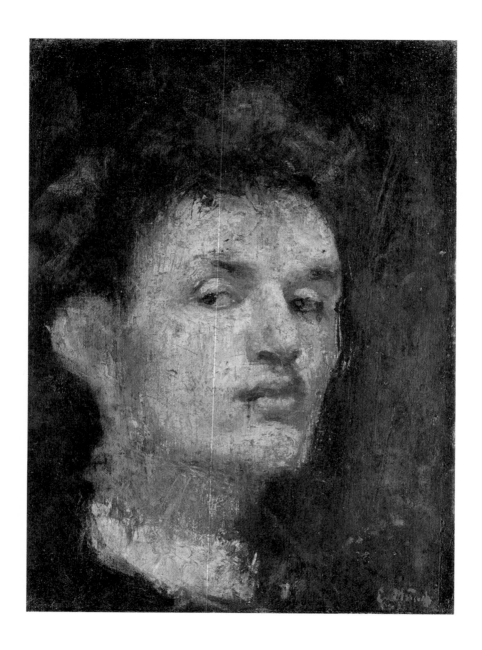

Self-Portrait, 1886, oil on canvas, 33 × 24.5 cm.

INTRODUCTION

THIS BOOK WAS BORN out of a wish to write an accessible introduction to Edvard Munch and his work. The existing literature on Munch is, of course, extensive and continually expanding, but it is also rather specialized, wide-ranging and fragmented. I wanted to create an up-to-date and reliable publication, written for a more general readership. This book gives the reader an opportunity to become more closely acquainted with an artist who historically has meant much to many – and who continues to do so today.

Why does Munch's oeuvre still fascinate us? Our preoccupation with Munch has reached new heights in recent decades, as demonstrated by record-breaking international auctions of his works and the writing of detailed doctoral theses about them. Large-scale exhibitions have been held at prestigious institutions such as the Museum of Modern Art (MoMA) and the Metropolitan Museum in New York, the Tate Modern in London and the Centre Pompidou in Paris. In 2013, the 'Munch 150' anniversary exhibition in Oslo attracted a total of almost 500,000 visitors to the Munch Museum and the National Museum. Why this huge interest? One reason is that Munch created a number of iconic modern paintings – visually arresting works that have

had an impact far beyond the initiated. *The Scream, Madonna, The Kiss, Vampire* and *Melancholy* – these are paintings many immediately recognize without necessarily knowing the name of the artist, or within what context the works were created.

But Munch's oeuvre extends far beyond these key pieces, and incorporates much of his time's secularization – the transition from a society rooted in religion to a more worldly or secular one. The fact that Munch had abandoned his childhood faith became evident early on, but his paintings still convey remnants of religious thoughts and ideas. He also developed an unusually wide-ranging sphere of interests and a diverse artistic register, producing portraits, landscapes, depictions of daily life, large figure compositions, small colour sketches, images of animals and interpretations of children. His works thematize the love, suffering and pain of the human condition, as well as the lyrical beauty of nature and the more mundane aspects of everyday life. Munch emerged as a painter, author, poet, graphic artist, draughtsman and photographer, and even created a few sculptures and films. His works bear witness to his multi-faceted and dramatically inclined nature; to an artist who was simultaneously a tradition-bound realist and an experimental modernist. He was an internationally oriented cosmopolitan, but also a person deeply rooted in place; a pillar of bourgeois society and a rebellious bohemian, both conventional and radical. Observation and reproduction remained important to Munch throughout his life – he was keenly aware of the world around him, taking note of novel ideas within the arts, popular culture, science and technology – and he reinvented his artistic style several times over. Not all his works will find favour with everyone – but many of them continue to have a huge impact on audiences across the world.

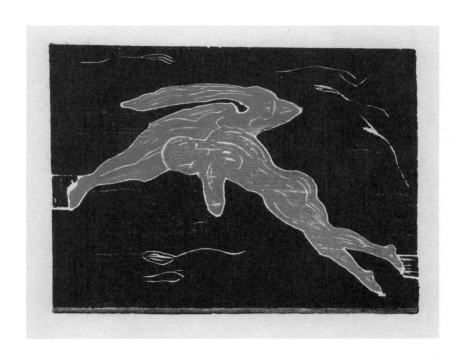

Encounter in Space, 1898–99, woodcut, 19 × 25.5 cm.

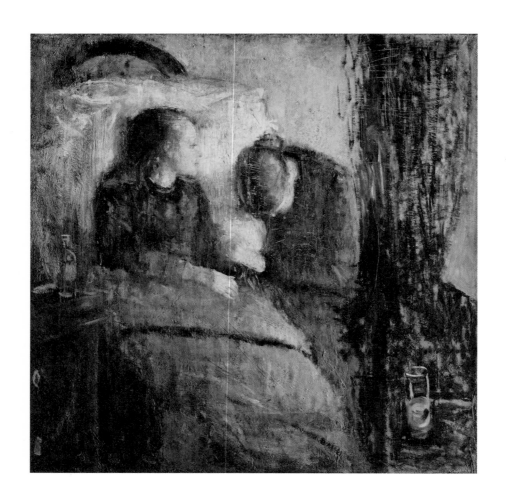

The Sick Child, 1885–86, oil on canvas, 120 × 118.5 cm.

KRISTIANIA IN THE 1880S

AMONG MUNCH'S ALMOST 1,800 KNOWN PAINTINGS, there is one that stands out. *The Scream*, you might say, undoubtedly the most famous and immediately recognizable of his works – an almost universal thematization of inner turmoil and feelings in motion. But the painting we will be looking at here is more realistic in style; with its heavy, dark atmosphere, it is reminiscent of paintings by Rembrandt and other old masters. Deep furrows, flecks and marks cause the image's various forms to merge into one another, drawing attention to the painting's physical traits. This work, *The Sick Child*,[1] reveals itself for what it actually is: colours and shapes set upon a flat surface.

A large, white pillow frames the painting's main subject, almost like a halo: the face of a pale, red-haired girl, turned in profile. Beside her sits a woman, her head bowed, but the girl is gazing instead towards the light streaming in through a fluttering curtain. This gives an impression of fresh air, in stark contrast to the illness that obviously threatens her young life. The figures are situated in the foreground of what is otherwise a fairly shallow pictorial space; the illusionistic effect is reduced. This is not an image we are invited to enter. The domestic interior is sparsely furnished: a rug, a nightstand,

a bottle, and a half-empty glass containing a red liquid. The two figures sit separately, but their hands seem to meet towards the centre of the image, as if in reconciliation or in prayer. The girl's face and hands illuminate the otherwise dark composition, attracting the viewer's attention and intensifying the drama the image conveys.

Throughout an artistic career spanning more than sixty years, Munch would return to this painting often – his first version of *The Sick Child*. He wrote about and alluded to the motif, coming back to and reworking it in various ways to create new versions.[2] Many have been fascinated by the work since it was first exhibited in 1886 at the Autumn Exhibition in Kristiania,[3] arranged by the National Gallery, under the title *Study*. It was a painting that visitors stopped to look at, criticize and pass comment on – perhaps even laugh at, due to its rough, reckless form. The painting seemed unaccomplished and unfinished, and was described by many as a miscarriage – a failure. Some even went as far as to claim that it should never have been accepted to the exhibition at all – that in fact, the painting was anything but art. But there were others who described the work as a gripping masterpiece, something unique created by one of the most promising artists of the age. The work was controversial, and soon gained notoriety – it was something people noticed and discussed. But to understand why the painting became such a 'succès de scandale', we must take a closer look at Munch's background, his life in Kristiania, and the art scene of the 1880s.

KRISTIANIA

In the 1880s, Kristiania (now Oslo) was a rapidly growing city characterized by optimism, modernization and the dawning of a new, national consciousness. The secession of Norway from Denmark in 1814 had initiated a nation-building process hitherto unparalleled in the country. Norway had become part of a union with Sweden, but the battle for increased independence

Karl Johan street in the 1880s, viewed from the Parliament building.

was intensifying – and this was particularly evident in the city that had recently earned the status of the country's new capital.

The Royal Palace, situated at the western end of the capital's main street, Karl Johan, was completed in 1848, and just a few years later the country's newly established university moved into three nearby monumental buildings, constructed in a classical style. Towards the east, the new parliament building, the Storting, was completed in the 1860s, and in 1874 the Grand Hotel opened its doors just across the street. The hotel's Grand Café became the meeting place of choice for the artists, writers and literati of the day, who would gather here to feel the pulse of the young capital. This circle became known as the 'Kristiania Bohemians', its members renowned for leading unconventional lives, challenging the bourgeois morality of the age, and speaking openly about sexuality and 'free love'.

Around the corner to the east, at Lille Grensen 7, was a building with large windows known as *Pultosten*. Many artists rented studios here – several of whom had recently returned home after many years spent studying abroad. Unlike their predecessors, young artists now favoured living in their homeland, creating fertile ground for a thriving art scene in the city, with

Pultosten acting as a kind of melting pot. Its milieu, as well as that of the Grand Café, would have a significant impact on Edvard Munch as an artist.

The city's art scene was part of the driving force towards increased national independence – and it flourished. One block away towards the north, in Universitetsgata, a dedicated building for the visual arts was opened in 1881: *Skulpturmuseet* (the Sculpture Museum), the central building of what would later become the National Gallery. Here, visitors could view works by old masters, casts of famous sculptures from antiquity, and paintings by renowned Norwegian artists such as Johan Christian Dahl, Adolph Tidemand and Hans Gude. Beyond this, the privately run *Christiania Kunstforening* (Christiania Art Society) dominated the art scene – but in the early 1880s the society was challenged by a new institution: *Statens Kunstutstilling*, popularly known as *Høstutstillingen*, or the Autumn Exhibition. This new institution was run by a younger generation of artists who were infuriated at the Christiania Art Society's lack of willingness to embrace new ideas – several of them had been refused exhibition space by the society's board, who viewed the realistic approach favoured by the young artists as somewhat vulgar and morally suspect. But now the artists themselves were able to decide what was good, bad or valid, and throughout the 1880s Kristiania developed into a modern, well-informed city of art.

At the same time, the city was growing – particularly out towards the west, as wealthier citizens purchased properties further and further from the city centre. In the east, the working-class district of Grünerløkka also expanded, with its characteristic apartment blocks arranged around open squares.

THE HOME

It was in Grünerløkka that medical officer Christian Munch settled around the mid-1870s, establishing his own practice to supplement his income. Accompanying him were the five

members of his family – and his Christian-Pietistic beliefs. His second oldest child, Edvard, was born at Løten in Hedmark in 1863.

Illness and death would hit the family hard. Just a few weeks after Edvard's fifth birthday in 1868, his mother died of tuberculosis, and her younger sister, Karen Bjølstad, assumed responsibility for running the household and raising the children. Until her death in 1931, Edvard Munch's aunt Karen would be the most important source of support in Edvard's life: '…it was probably she who contributed most to my becoming a painter', wrote Munch in a letter to the director of the National Gallery, Jens Thiis, in 1933.[4] Aunt Karen was interested in drawing and handicrafts, and encouraged Edvard in his artistic endeavours. As the years passed, her belief in his talent remained unshakeable.

In 1877, the year that Edvard would turn fourteen, his older sister Sophie also died of tuberculosis – neither his father's belief in God nor his medical knowledge was enough to save her. Edvard, too, was ill for much of his childhood, which affected his attendance at school. Illness and death were themes that Munch would often return to in his works. By the autumn of 1880, he had decided to become an artist: 'Monday the 8th. I have once again resigned from the technical college. My decision is now to become a painter.'[5] By the time of his death over sixty years later, in January 1944, Edvard Munch would become the most famous and important artist in Norwegian history.

LITTLE EDUCATION

Munch completed no course of higher education; nor did he apply to any academy. He studied at the Christiania Technical College for one year, and then at the Royal School of Drawing, under Julius Middelthun. But Munch subsequently operated on his own – or, more accurately, he worked together with other like-minded colleagues. This lack of formal education was in fact very much a generational phenomenon

The living room in 7 Foss Road, 1879–80, watercolour on paper, 15.5 × 15.6 cm.

Karen Bjølstad by the Window, 1882, ink on paper, 25 × 15 cm.
Inger Munch, 1882, charcoal on paper, 34.6 × 25.9 cm.

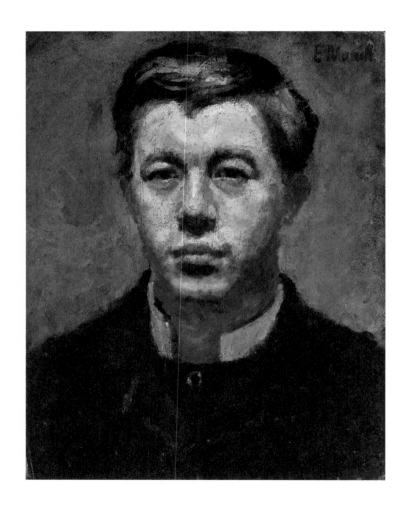

Thorvald Torgersen, 1882, oil on board, 35.5 × 28 cm.

– a striking number of Munch's young artist friends never undertook any academic training. They opposed the established system, and broke away from the types of art that dominated the large academies. In 1883, Munch joined forces with several of his peers to obtain a studio in *Pultosten*. They painted portraits of one another, went on field trips, tried painting outdoors, and were corrected, advised and guided by slightly older artists inclined towards realism such as Christian Krohg, Frits Thaulow and Erik Werenskiold. These older artists had been educated in Germany, but were deeply interested in the advanced contemporary painting being produced and exhibited in Paris. Thaulow was Munch's relative and would become important in several ways, as a source of both inspiration and support. Of all the Norwegian artists, it was he who most wholeheartedly followed the impulses of the new, advanced painting style from Paris; the impressionists' *plein air* approach of painting outdoors was communicated to the younger artists through him, and they travelled to areas such as Modum to paint out in the open, immersed in nature. Thaulow emphasized the value of art for art's sake, while Krohg was a figure painter who placed greater emphasis on the ways in which art could highlight social conditions and set forth problems for debate. Krohg became the closest thing to a teacher Munch would ever have.

At first, Munch described himself as a 'genre painter'[6] – someone who depicts ordinary people in everyday situations. The painting *Morning* (overleaf) gives us an idea of his initial direction: a young woman sitting on an unmade bed. The choice of a prosaic subject and the absence of any idealization is characteristic of the era's down-to-earth ideals. An underlying sensuality is also apparent in the image – a subtle expression of intimacy. The young woman has stopped in the middle of getting dressed, seemingly lost in thought. What is she thinking about? The depiction of the light and the way she distractedly strokes the skin of her arm hints at something sensual. Early in his career, Munch became interested in depicting

young women in vulnerable situations, and experimented with large canvases that enabled him to explore abstract qualities relating to colour and painterly technique. The rich spectrum of various shades of white in this piece is striking, as is the cool blue against the woman's reddish hair, applied with a slightly rough, tattered paintbrush. The work's overall clarity has much in common with Krohg's painterly realism,[7] but Munch places greater emphasis on nuances and the effect of colour. Such peaceful figures in quiet moments of contemplation were a popular motif among painters of the time, being well-suited to depictions of a piece of observed reality interpreted by an engaged subject. Krohg and his colleagues made the words of the French realists their own: 'A work of art is a corner of reality seen through a temperament.'[8] In his paintings, Krohg expressed his empathy for ordinary, hard-working people. In Munch's work, however, it is not the work, hardship and social conditions that attract the viewer's attention, but rather the image's atmosphere and its subject's state of mind.

It was the ideal of the age: to depict what one saw directly and realistically, but still in a subjective way – the artist's personality should be evident in the work's execution. The realists felt it was important to paint what they saw, but the painting should still clearly be a painting – it shouldn't attempt to approximate a photograph. Krohg spearheaded this approach.

For any young artist wishing to be modern, it was critical to work with ordinary, everyday motifs. Magnificent landscapes featuring mountains and deep valleys were no longer relevant in the way they had been for the older generation, who were referred to as romantics – instead, one's immediate surroundings were now the order of the day. For the realists, anything could be painted – as long as it was painted well. With mottoes such as 'I paint what I see',[9] the aim was to reproduce reality as if 'seen through a hole in the wall'.

It was also important to be of one's time – to paint the images of one's age – and the new *plein air* approach supported

Morning, 1884, oil on canvas, 96.5 × 103.5 cm.

this. Painting outdoors, directly opposite the subject, involved an adherence to the situation in the here and now. The approach was also versatile, able to reflect either the rural lifestyle or the modernization that characterized the cities, with their smoking factory chimneys, spectacular railroads, and people busily hurrying back and forth.

The romantics had also painted outdoors, but mostly to sketch and make studies for the large compositions that they created in their studios; whereas in their accentuation of the truth, it was important for the realists to complete their paintings directly opposite the subject. Another important factor was that the sketch's carefree, vigorous brushstrokes more spontaneously communicated the artist's personality and sensitivity, or 'temperament'. Munch's anti-academic attitude became apparent early on. He did not copy the old masters, and nor did he undertake significant preliminary studies or create transfer drawings for use in his paintings. The image was created directly on the canvas.

GRÜNERLØKKA AND KARL JOHAN

Two cityscapes showing places that Munch knew intimately epitomize his work throughout the 1880s: *Afternoon at Olaf Rye's Square* and *Spring Day on Karl Johan* (overleaf). The first shows the view from Munch's home, the second the city's main thoroughfare.

Among the Norwegian artists it was Frits Thaulow[10] who had introduced the city as a subject, painting deserted streets, views of Paris, or people sauntering through Kristiania's Palace Park. In such cityscapes the fascination for *plein air* became clear – few Norwegian artists had previously shown interest in the genre. Moreover, urban environments also contained something genuinely contemporary: modern people wearing modern clothes.

Traces of Thaulow are striking in Munch's little painting from Olaf Rye's Square. The perspective is from slightly above the square, probably from one of the Munch family home's windows. Small figures can be seen out taking a stroll; some

sit on the grass. The impression of sunshine and summer in the city is communicated through a light and airy execution, with distinct colours applied using short brushstrokes.

The painting from Karl Johan is larger, clearer in its composition, and more confidently executed. Here, too, the loose style allows for the accentuation of atmosphere, light and movement. But this painting is no small, quickly painted study – it is a more unified work. The vantage point is the corner of the street towards the Storting, and the elements are gathered under a perspective that draws the eye towards the Royal Palace in the background. The subject was one of the most popular Kristiania had to offer, a favourite with photographers and much used on postcards. The painting's execution has much in common with the advanced painting of the time, the colours applied more systematically, in unblended dots. It is also striking how some of the figures in the foreground are roughly cut off, giving the impression of something fleeting and incidental, as in a hastily snapped photograph.

The first painting demonstrates that as early as 1883, Munch had made the choice to adopt the new *plein air* approach, thereby taking up a position that opposed the point of view of older romantics and younger realists. This conflict was most clearly evident in the relationship between the Christiania Art Society and the Autumn Exhibition. The Art Society held an idealistic view in which the purpose of art was to depict reality, but with the aim of presenting something beautiful, magnificent or elevated – art could thereby have a formative effect on the mind. The romantics worked in the Renaissance tradition, and emphasized the use of illusionistic spatial effects, so that viewers would feel they could simply walk into the painting. The colours should be muted, mixed into various shades and subject to a balanced composition. The realists, on the other hand, preferred light and pure colours presented as they appeared in reality, and valued truth over beauty. Art, they believed, should be in more direct contact with life as lived, and with that which the artist actually observes.

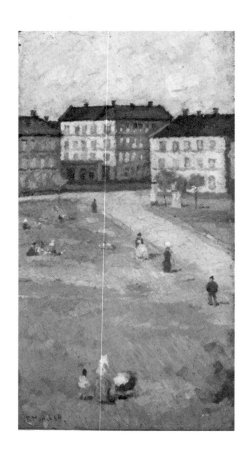

Afternoon at Olaf Rye's Square, 1883, oil on board, 47.5 × 25.5 cm.

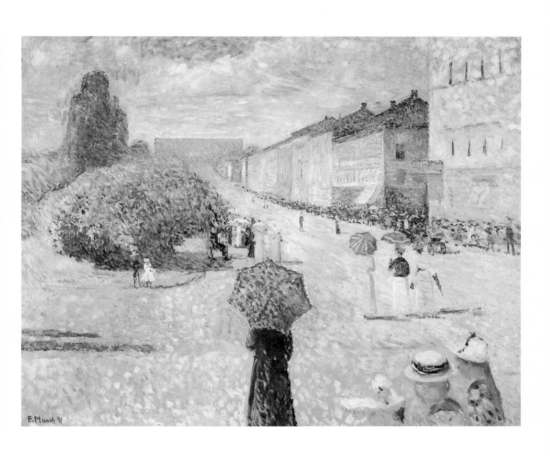

Spring Day on Karl Johan, 1890, oil on canvas, 80 × 100 cm.

The realists were an expression of the new. They were controversial, but they were seen and heard – works by some of them were even acquired by the National Gallery. They also had the era's most eminent critic on their side, the knowledgeable art historian Andreas Aubert. But for the generation that followed them, the pressing question was which course to pursue after realism. Munch's slightly older colleague Gustav Wentzel took a clear stance with his almost photographic works featuring prosaic, everyday motifs. Here, the realists' idea that a painting should depict reality as 'seen through a hole in the wall' was executed with amplified consistency. Others went in the opposite direction, placing greater focus on how brushstrokes, colours, and the painting's materiality could communicate atmosphere, subjectivity and something beyond the actually observed. Munch was groundbreaking in this regard, and he and Wentzel therefore represented two alternative strategies: two extremes among the young artists of their time.

IMPRESSIONISM

The situation within the art world was radicalized by a new phenomenon: impressionism. Throughout the 1870s, a number of French artists had worked in opposition to the established art scene in Paris. They were marginalized by the system and thus chose to arrange their own exhibitions, which aroused considerable controversy and consequently attracted significant attention.

Today, it can be difficult to understand why the paintings of the impressionists gave rise to such intensely negative reactions, but at the time they were seen as a radical break from traditions that had been established over hundreds of years. Unmixed paints were applied directly to the canvas alongside one another in a methodical pattern of disconnected strokes, resulting in clear marks and traces of the artist's process on the painting's surface and disrupting the illusionism. The technique was soon termed 'dot-painting' – an intentionally

derogative summary of the impressionists' method. The compositions also seemed random, with subjects being sharply cropped – a technique Munch used in *Spring Day on Karl Johan*. Dynamics and people in motion replaced harmony, details and balance. Impressionism became the point of departure for something new: modern painting.

Though impressionist works had not yet been exhibited in Kristiania, the phenomenon was well-known among the city's art circles. In 1882, both Krohg and Werenskiold visited one of the impressionists' exhibitions in Paris, and the latter wrote about it for Norwegian readers.[11] Werenskiold was intrigued by the effect of light in the impressionists' paintings; the choice of odd perspectives and the use of 'random' sections. Less competent critics, however, used the term 'impressionism' as an insult. It became a shorthand for the decline of modern art and the young's quest for frivolous scandal. In 1885, Munch participated in the Autumn Exhibition with a painting that showed how he combined impressionistic elements with an interest in the old masters and more recent artists, such as Thomas Couture and Edouard Manet.[12] The *Aftenposten* newspaper's critic viewed Munch's full-length portrait of his bohemian friend Karl Jensen-Hjell (overleaf) as '…Extreme impressionism. The distortion of art'.[13] But with the painting, which garnered much praise among experts, Munch successfully positioned himself as a radical revolutionary. It would be several years before he followed in impressionism's footsteps more consistently, but at the following year's Autumn Exhibition he would come to fervently challenge the current definition of art.

THE WORK OF MEMORY?

The Sick Child can be regarded Munch's first step in his journey to become one of the great, groundbreaking artists of his time. With the exception of one small self-portrait, *The Sick Child* was not particularly representative of what Munch was producing throughout the 1880s. The painting manifests a desire to

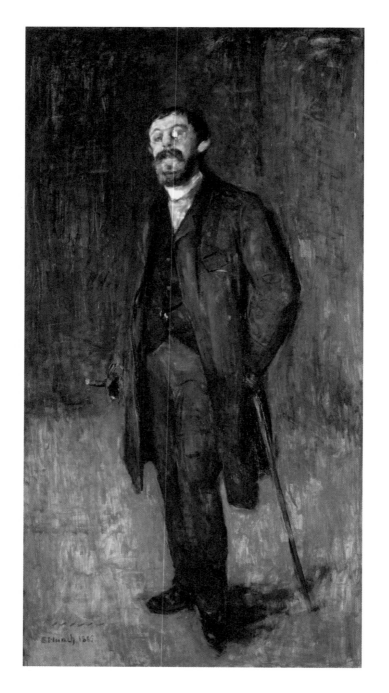

Karl Jensen-Hjell, 1885, oil on canvas, 190 × 100 cm.

surpass the conventions of the age and the ability to shatter the limitations of what art could be, anticipating aspects of the new, modern painting. Later in life, Munch himself would refer to the painting as his artistic breakthrough: 'Most of what I have done since was born in this painting.'[14]

Was it Munch's strategic rebelliousness that gave this painting its remarkable appearance? Or was its form driven by a personal and emotional knowledge of the subject? What did this painting mean in the context of Kristiania in 1886? What did it mean to Munch later in life? What does the painting appear to be about for us today?

There are several established perspectives from which we can view *The Sick Child*. One of them relates to Munch's quest to develop an independent standpoint beyond the realism of the age. In the 1880s, 'sick girls' were a popular motif, particularly among artists wishing to depict an unembellished reality. Munch would later describe the era as 'the Age of the Pillow', since to paint bedridden women was 'just as common as painting apples on a tablecloth'.[15] Both Krohg and Hans Heyerdahl had painted sick children with great success, but why did Munch choose the same motif? Perhaps he wanted to try his hand at – and surpass – the techniques of his slightly older, established colleagues? To test the conventions of the age? To be the most daring of them all?

It wasn't the motif that attracted attention and outrage, but the painting's execution: the slovenly, reckless style; the absence of compositional integrity; and the dispersed figures and unclear details that made the painting seem unfinished. Munch was already notorious for not completing his paintings, but with *The Sick Child* he went even further – this time, even his supporters, such as Krohg and the writer Hans Jæger, felt he had gone too far. Of all of them, it was perhaps Aubert who most clearly expressed the objections to the painting:

> There is genius in Munch. But there is also the risk of it going to the dogs....For Munch's own sake, I therefore

hope that his sick child will be rejected....As this 'Study' (!) currently stands, it is no more than a discarded, half-finished rough sketch. He has been worn out by the work. It is a miscarriage.[16]

Harsh words from one of the most important art critics of the day – the man who had fought for the realists and the *plein air* painters to be given the recognition they deserved. But Aubert's argument touches on some fundamental questions about modern art in general. Where is the line between a draft, a sketch and a completed work? When, and through what means, does a painting become art? What *is* art?

What the painting presented was overshadowed by how Munch created it. Aubert could surely appreciate certain qualities in the work, but the critical question was no longer whether the painting was executed skilfully or poorly, but whether or not it was art. In this sense, *The Sick Child* typifies a more complex phenomenon within the leading art of the late 1880s: the production of artworks that challenged the age's very definition of art.

The Sick Child can also be understood biographically. Since Munch's father was a doctor, it seems likely that Munch might have been familiar with this kind of scene, having perhaps accompanied his father on home visits to patients. He had also lost his mother and his sister to serious illness, and the painting is therefore often understood as a personally formulated work of memory associated with the loss of Munch's older sister Sophie in her youth. But Krohg and Heyerdahl also lost siblings during their childhoods, without this fact coming to dominate the understanding of their versions of the motif. It is worth noting that none of Munch's contemporaries stressed the importance of the death of Munch's sister in their interpretations of the painting, and nor did Munch himself. Yet this biographical understanding remains strong because Munch is often regarded as an autobiographical artist, and because the work is formu-

lated in a way that is connected to subjective engagement and emotional involvement.

Biographical interpretations of Munch's works generally used to be more dominant than they are today.[17] In recent decades interest in his work has moved towards cultural, historical and contextual approaches. Munch himself placed great emphasis on the difficulty he had experienced in creating the painting – how he had wished to return to the first impression and the underlying mood of the subject. This initial impression had occurred during a hospital visit, where he saw a sick, red-haired girl:

> When I saw the sick child for the first time – the pale head with the vibrant red hair against the white pillow – it made an impression that disappeared as I worked on it. – I achieved a good yet different picture on the canvas. – I painted the picture numerous times in the course of a year – scraped it – dissolved it in generous applications of paint – and endeavoured again and again to attain the first impression – the translucent, pale complexion against the canvas – the quivering mouth – the quivering hands. –[18]

The painting's materiality – composed of many layers on top of each other – confirms Munch's description of the process of creating it as a lengthy one. Did Munch also regard the work as a failure? He would eventually move away from this laborious approach, but his experience of painting *The Sick Child* turned him on to something important: the value of retaining the immediate – that initial, inciting impulse, the emotional impressions, the fleeting mood. Perhaps people were right when they claimed the painting was a failure. But the aspects of the work that were received negatively when it was first exhibited are the very same traits that would later give it a prominent position as one of early modernism's most significant works.[19] With *The Sick Child*, Munch paved the way for new ideas. The painting opened up the possibility of highlighting aspects of reality other than the tangible and observable.

The absence of details and depiction of the surrounding environment releases the subject from time and place, and so a connection arises to another well-known image of loss in Western art – the portrayal of the Virgin Mary grieving for her dead son, Jesus, most famously in the form of the *Pietà*, Michelangelo's marble sculpture from the late 1400s. Here, the religious motif was given a new, worldly dimension. Michelangelo chose to depict a holy mystery from Christianity, but also emphasized the fact that the Virgin Mary was an ordinary mother who had lost her child. The sculpture therefore soon became the great reference point for depictions of human loss. With his personal approach, Munch added an emotional dimension to the portrayal of loss. The execution of *The Sick Child* explicitly connected the painting's form with one of the most difficult of life's experiences: that of losing a child.

GIRL TO WOMAN

Girls and young women populate many of Munch's works from the 1880s, often depicted in situations that render them vulnerable. Within this preoccupation lies the seed of what would become a central, recurring theme in Munch's work – the portrayal of women in various situations and stages of life. An early example is the portrait of his youngest sister, Inger, wearing her black confirmation outfit, on the cusp of adulthood (page 54).

Some years later, in the wake of his encounters with the Kristiania Bohemians, Munch developed two of his most controversial depictions of women: *The Day After* and *Puberty*[20] (overleaf). The first versions were lost early on, and so the paintings are known to us through later editions, created in the 1890s. *The Day After* was quickly understood as a portrayal of the debauched bohemian lifestyle. In public, hair worn loose and bare skin were signs of frivolity and the absence of morals, but among the bohemians these things represented emancipation and rebellion against society's established gender roles.

But the painting contains an unanswered question: what has happened? What occurred during the evening and night before 'the day after'? The bottles and glasses imply the consumption of alcohol, and the presence of someone else. Did it all become too much – did the situation get out of control? The woman's open blouse, along with the fact that she is lying atop the sheets, rather than under them, may hint at this.

An ambiguity relating to gender and sexuality arises in Munch's painting. Note the vertical, phallus-like shapes, the loose material of the woman's dress, and what is implied by her outstretched hand – can we make out the contours of a vulva? Munch's simplification of shapes and sketch-like style made it possible to articulate these kinds of symbolic details. They create drama and charge the image's mood, almost without our even noticing them. Munch's motifs often defy any single, definitive interpretation.

Is the woman a liberated bohemian, freely rebelling against the expectations of respectability placed upon her by a strict, patriarchal society, or has she been taken advantage of by someone who has got her drunk and assaulted her? Some of the durability of Munch's oeuvre undoubtedly arises from a desire to capture the essential, and the ability to develop simple, recognizable motifs. But it is also about the art of suggestion, and rendering messages ambiguous.

The circumstances of young women and their vulnerability in society was a theme that occupied many, even beyond bohemian circles. In 1883, Jonas Lie published his novel *The Family at Gilje*, which follows three daughters on their journey into adulthood. The book's protagonist, Inger-Johanna, never experiences a fulfilling relationship, but becomes an independent governess. This interest in women's private lives and suffering came to the public eye in the spring of 1886 with Christian Krohg's novel *Albertine*, the story of a poor young woman who is exploited and forced into prostitution. The book was immediately banned, but the court case surrounding it caused a public furore. A few months later, Krohg even exhibited a large-scale

The Day After, 1894, oil on canvas, 115 × 152 cm.

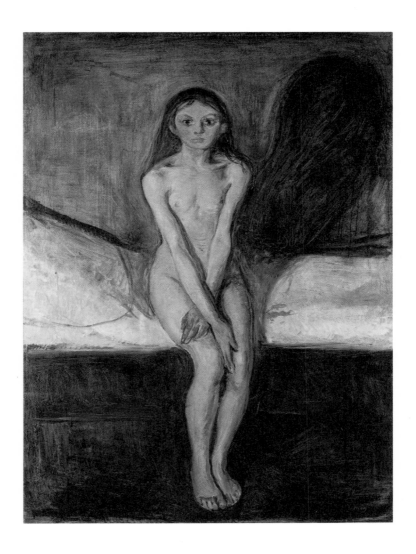

Puberty, 1894–95, oil on canvas, 151.5 × 110 cm.

painting based on one of the book's key scenes: *Albertine to see the Police Surgeon* (1885–87).

Few artists have formulated such an overtly direct and unified image of the transition from child to woman as Munch did with the painting *Puberty*. Begun as early as 1886, this was his first iconic motif, in which he moved towards concentrating the expression in a striking, stylized main form. Several of his most famous works are based on a similar formula: one or two figures arranged frontally, face to face with the viewer in a way that covers large areas of the image, often with few concise details and little pictorial depth. In *Puberty*, we are confronted with the exposing nature of the girl's nakedness, and her emotional state. She is obviously embarrassed, covering her genitals and looking at us with wide eyes. We look at her, but she also looks back at us. We are drawn into the painting's psychological drama – the girl has been rendered vulnerable.

Puberty was Munch's first large-scale female nude – among radical artists, the female nude had become a topical genre. In 1865 Edouard Manet's controversial *Olympia* had set a new standard, in which women were depicted without religious or mythological references and with sexual ambivalence: depictions of naked women for an audience dominated by men. But *Puberty* is different. Here, we are unable to evade the subject's vulnerability and the situation's uncomfortable sense of exploitation – an exploitation that is also about the relationship between male artist and young, female model. The painting's original title, *Model for the First Time*, emphasized this dynamic. But the image is neither racy nor sensually alluring – it is charged with unease, as is made clear by the large, looming shadow on the wall behind the bed. The work bears witness to a sense of empathy with the girl's situation, over which she apparently has no control, and her dawning sexual awareness – a dimension with which Munch as a man could not identify, but only empathize. This points to another quality that Munch possessed and articulated in his art: the ability to imagine and sympathize with other people's circumstances.

Puberty is a critical stage in a person's development from child to adult, and the late 1800s saw a growing awareness of adolescence as a unique stage in life. People began to understand that this phase is not only about bodily and sexual changes, but also about psychological and emotional challenges. Munch's painting fixes this process in a specific moment, but also illuminates something timeless and recurrent. Puberty is a phase that everyone must go through, and these kinds of threshold experiences and transitional phases were something that Munch would become highly interested in, those moments where the spark of life interrupts the death drive: transformations, transitions, things that mix together, fusions and metamorphoses.

Many reacted negatively to *The Day After*, *Puberty* and other paintings with such shameless or 'indecent' motifs – and then there was the connection to the Kristiania Bohemians, as well as the fact that the images looked so carelessly executed and unfinished. But among like-minded individuals and people who sympathized with radical positions, Munch's reputation was on the rise. In short, these works confirmed Munch's position as a controversial artist throughout the 1880s. This reputation would continue to precede him for several decades – but also ensured that his name was known in the art world. Notorious and condemned he might be, but also renowned.

ARTIST PORTRAITS

Munch worked extensively with portraits from the very start of his career, which was perhaps unsurprising considering he was related to one of the country's foremost portrait artists: Jacob Munch (1776–1839). At first, Munch's portraits were of family members and fellow students, in small formats where he focused on presenting the face with interpretations of the sitter's personality. But with the aforementioned full-length portrait of his artist friend Jensen-Hjell, he significantly expanded the format in which he worked. The genre had its roots in the culture

of the European upper classes, and was traditionally reserved for the well-off individuals who inhabited these upper echelons of society. There was something seemingly disrespectful in Munch giving such attention to one of his drinking companions: through the genre of large-scale portraiture, Jensen-Hjell was set on equal footing with high-ranking statesmen. Such self-confident portraits were created by the Krohg generation as part of their insistence on the importance of the artist in society: Krohg painted Gerhard Munthe drinking at the Grand Café, while Werenskiold immortalized bohemian professor Amund Helland. Munch took as his subject the leading figure within the Kristiania Bohemian circle: Hans Jæger.

There is something ambiguous about Munch's collegial portraits. Their subjects are exalted and celebrated, but the paintings also contain elements of ironic disclosure – they simultaneously support and caricature the artists' cocky belief in themselves and in the importance of their vocation. Some years had passed since indecency charges had been brought against Jæger for his book *Fra Kristiania-Bohêmen* (1885) when Munch began work on the portrait. Jæger had served his prison sentence and lost his job as a minute-taker in Parliament, and his position was on the wane even within his own circles. But in Munch's portrait, Jæger is depicted nonchalantly lounging on a sofa. The angle of the table, slanting towards the foreground, draws us into the image, which is painted in a free and easy realist style, without many details. But why is Jæger wearing his hat and coat? He seems self-assured, but also strikingly reserved; buttoned-up. Several established minor motifs and details that recur in many of Munch's paintings in various contexts are included, such as the glass in the foreground and the cutting diagonal line. The table's edge seems to point towards Jæger's heart – the organ that was of such importance to Jæger as a seeker of truth. The portrait bears witness to an ambivalence towards the sitter. This is particularly evident in the face, which has both a sympathetic and a diabolical side.

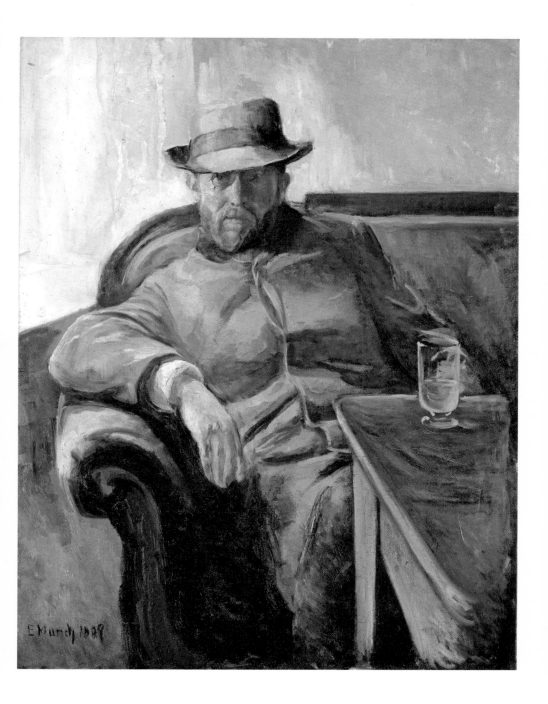

Hans Jæger, 1889, oil on canvas, 109 × 84 cm.

THE DRAUGHTSMAN

As previously noted, Munch lacked much formal education, but he did receive thorough training in the mother of all arts: drawing.[21] He continued to draw throughout his life – creating everything from academic exercises and detailed studies to quick impressions, cartoons, jokes and commentaries. He also explored erotic motifs, sometimes overtly and directly. His portraits and larger preliminary sketches exist alongside such informal depictions of everyday life. His sketchbooks are like journals, highlighting the lesser-known sides of Munch as an artist: here, Munch the humourist and satirist is more apparent, and he presents various types of 'enemy' via revealing ironic depictions and caricatures.

While most artists prefer to concentrate on a few favoured drawing techniques, Munch explored many, using ink, pencil, charcoal and watercolours. Perhaps it was through drawing that he first developed his broad field of interest – his desire to experiment with every tool available to him – and his ability to diversify.

For Munch, drawing as an act and exercise was just as important as the end result, and he developed a more spontaneous and intuitive method through his experimentation with drawing techniques. The accentuation of the hand's immediate movements reduces the distance between the image and the impulse and feeling behind it, and the material shows how a motif might arise and be developed. The extent to which Munch regarded his drawings as independent artworks is debatable, but he included at least some of them in several of his exhibitions. Above all, these works bear witness to a thoroughly investigative, analytically inclined and methodical artist. Much work went into the spontaneous, direct form of expression that would become so characteristic of Munch's style.

ÅSGÅRDSTRAND

During the 1880s, the Munch family rented a house on the west side of the Kristiania Fjord (Oslo Fjord) for the summer holidays. In 1885, they ended up south of Horten, not far from the port town of Åsgårdstrand, and the family's stay here would be formative for Munch in several ways. At the age of twenty-one, Munch fell in love – an overwhelming experience to which he would continually return as a source of artistic inspiration later in life. He experienced new emotions intensely at this time, but the relationship itself, with the slightly older Milly Thaulow, ended unhappily. Milly was married to Frits Thaulow's brother Carl, and belonged to the outer circle of Munch's acquaintances. In his later writings about her – of which there are many – Munch gives Milly the name 'Mrs Heiberg'. A long line of passionate relationships with young, beautiful women with strong personalities followed this affair. The closest he ever came to marriage was his turbulent relationship with the wealthy Tulla Larsen around the year 1900, but Munch ultimately remained unmarried and lived alone for his entire life. He would, however, use his experiences from these relationships as material for many of his paintings, but in a way that went beyond the specific and the private. From early on, Munch developed an ability to generalize and develop motifs that were more universally applicable and true.

The area in and around Åsgårdstrand would become highly significant in Munch's development as an artist. From the summer of 1889, and over many subsequent years, Munch would spend almost every summer here. He produced a considerable number of works based on the area's environs, and purchased a fisherman's cottage just outside the town centre in 1898. This was his preferred place of residence for many years, 'the only agreeable house I have lived in'.[22]

Over the years, Munch developed a number of motifs from Åsgårdstrand: the curving shoreline, the surface of the fjord as seen from the edge of the forest, parallel tree trunks, the pale gloaming of a summer evening, and the moon with its

Standing Male Nude, 1889, charcoal on paper, 62.5 × 47.7 cm.

Caricature. Johan Sverdrup, c. 1885–86, pen on paper, 22 × 14 cm.
Caricature. The Author Bjørnson on the Norwegian Cultural Scene, 1891, pen on paper, 21.6 × 35 cm.
Caricature. Gunnar Heiberg as a Pig and a Toad, 1907–8, charcoal and watercolour on paper, 47 × 30.9 cm.

Interior with Family Members Sleeping, c. 1885,
pastels and pencil on paper, 28.8 × 35.8 cm.

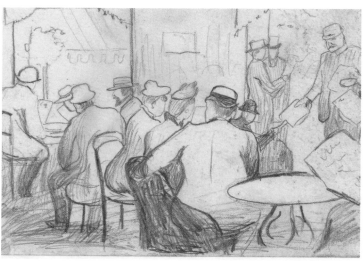

Adieu (Kiss), 1889–90, pencil on paper, 21.7 × 20.7 cm.
Café Scene, 1890–92, pencil on paper, 25.2 × 17.9 cm.

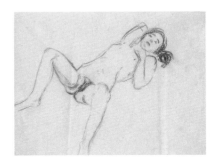

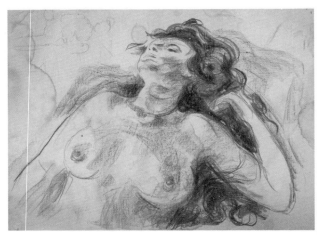

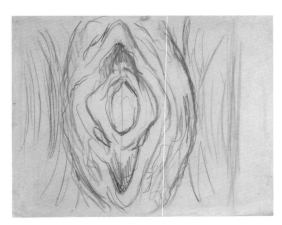

Reclining Female Nude, 1911–15, charcoal on paper, 25.5 × 32.2 cm.
Reclining Nude I, 1920, crayon, 59.8 × 81.8 cm.
Sketch of a Vulva, 1907–8, charcoal and pencil on paper, 53.8 × 67.8 cm.

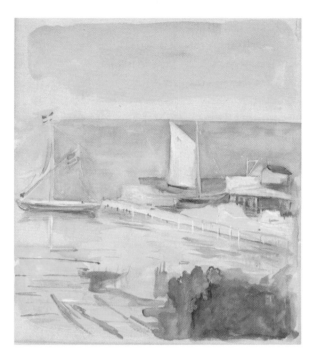

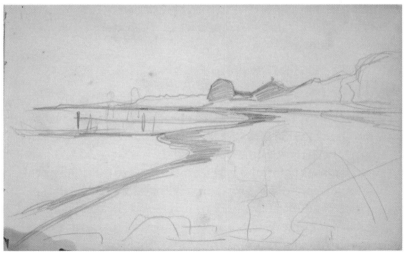

Åsgårdstrand Pier, 1889, watercolour on paper, 28 × 23.2 cm.
Beach Landscape, Åsgårdstrand, 1891–92, pencil on paper, 17 × 27 cm.

vertical column of light. He also took inspiration from life within the small town, but Åsgårdstrand's true significance begins with a portrait. In *Summer Night. Inger on the Beach* (page 54), we again encounter Munch's sister Inger, but this time as a young woman dressed in white, sitting by the water's edge. She appears lost in thought in the light summer evening; the water's surface fills the background, reducing the painting's depth so we look down towards the water, not out towards the horizon. The elements slide into one another: figure, stones and water. The work shows another side of Munch as an artist – the lyrical naturalist and painter of moods, an extension of the neo-romantic movements of the time. During the latter half of the 1880s, a change occurred among many of the age's prominent artists – a growing interest in mood, reminiscence and romantic feeling for the beauty of nature, first noted at the so-called *Fleskumsommeren* art collective in the summer of 1886.[23] A few years later Munch created yet another portrait of Inger, this time in a frontal, monumental full-length version (page 55). The three paintings of Munch's youngest sister show three differing approaches to the genre of portraiture. Viewed collectively, they anticipate Munch's later depictions of women at various stages of life.

SOLO EXHIBITION

When the painting of Inger on the beach was exhibited at the Autumn Exhibition in 1889 it aroused considerable enthusiasm among the artists – Erik Werenskiold even went so far as to purchase it. As before, however, others pointed out the work's faults and weaknesses. Perhaps it was in part Munch's ambition that provoked such reactions? He had already held a large solo exhibition the previous spring, the aim not necessarily being to find buyers for his paintings, but rather to obtain something even greater: the state scholarship for artists. In order to achieve this, however, he would have to convince the panel of judges – he had applied for the scholarship the year before,

but been rejected. There were still many things that counted against Munch and his development as an artist. Undoubtedly, he had talent – that was generally agreed upon. The problem was his apparently rough, slovenly style – in addition to his association with the much-despised bohemians.

Munch used the solo exhibition to garner confidence in his work. Holding such solo exhibitions was not usual at the time, but Munch took a chance, and at the very last minute even managed to complete a work that might prove convincing – the painting *Spring*. In it, Munch returned to the themes of *The Sick Child*, but in a far more thorough and conventional way. The painting seemed much more complete, in terms of both its composition and its depictions of figures and details. *Spring* (1889) and *Inger on the Beach* were in accordance with the aesthetic ideals of the time; the former in line with painterly realism, the latter with neo-romanticism. Together, they helped to ensure that Munch was finally awarded the distinguished scholarship, and with it the ability to travel abroad. He was, however, expected to undertake further study in order to remedy his weaknesses in anatomy, detail and execution. A period spent studying at Léon Bonnat's academy in Paris was presented to Munch as, essentially, a prerequisite for receipt of the scholarship. But over the years that followed, it would be the experience gained from painting *The Sick Child* that would guide Munch, and nobody understood or expressed this more clearly than Krohg, Munch's former mentor and teacher:

He paints – that is, *sees* – differently from other artists. He sees only the essential, and so of course paints only this. Munch's paintings therefore generally appear 'unfinished', as people are so eager to point out. But – yes! They *are* finished. Finished by his hand. Art is finished when the artist has truly said all he wished to say, and it is precisely this advantage that Munch has over the second generation of painters, that he is quite different in understanding and showing us what he has felt; what has gripped him to the

subordination of everything else. That this occasionally comes at the expense of other things, and that he is forced to give up much of what constitutes good drawing, is certain. But people should be glad of this, because one fine day he will conquer all of it, and portray the essential without needing to give up drawing, etc....It is a shame that Munch has not had the opportunity, as all the French painters have had, to attend a thorough course of study at an academy, because Munch is so original that this would have done him no harm, as it has done to so many others.[24]

It was probably a great help that several of the established artists of the time supported Munch's candidacy for the scholarship – they even had his paintings hanging on their walls! Thaulow bought *Morning* (1883), Werenskiold the portrait of Inger, and Munch gifted *The Sick Child* to Krohg.[25] Throughout the 1880s, Munch's reputation as a controversial and much criticized rebel grew – but his colleagues put him on a pedestal. He had the necessary talent, desire, courage and not least strategic aptitude to make a success of himself, and his conception of *The Sick Child* in particular had set him on a certain artistic course – to grasp tightly and fix the initial impulse and fleeting mood. The importance of intuition in his work became clear – he was now on the path to painting moods and emotions.

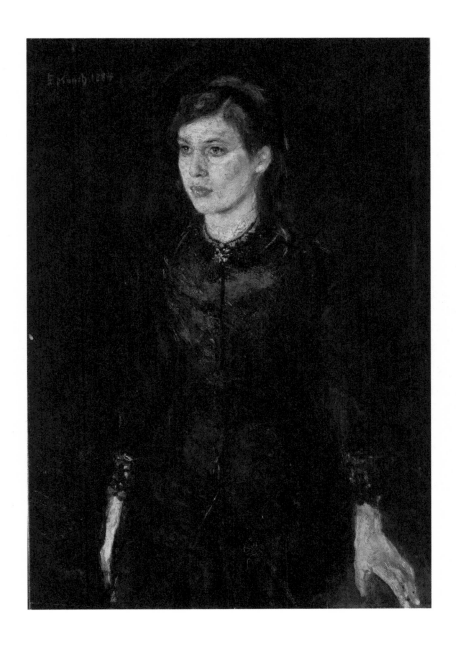

Inger Munch in Black, 1884, oil on canvas, 97 × 67 cm.

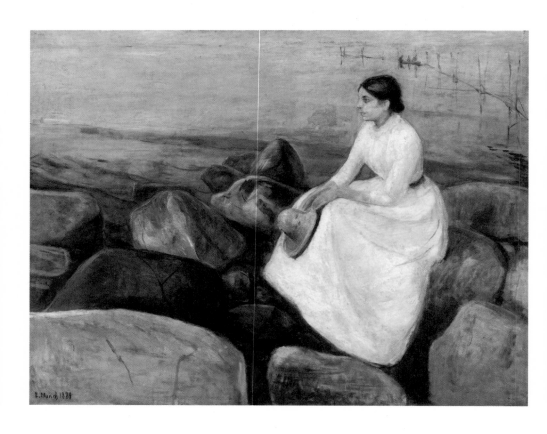

Summer Night. Inger on the Beach, 1889, oil on canvas, 126.5 × 161.5 cm.

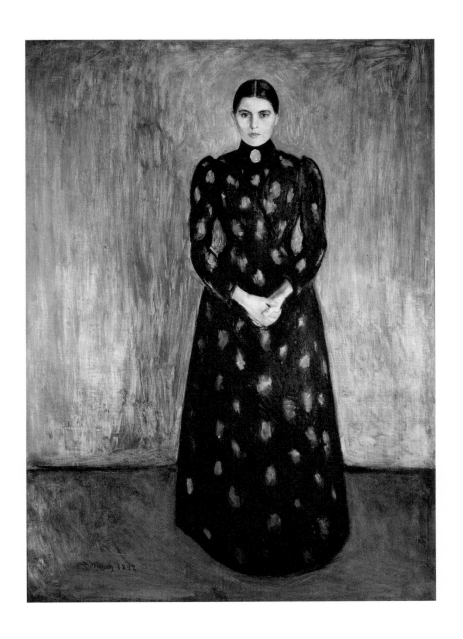

Inger in Black and Violet, 1892, oil on canvas, 172.5 × 122.5 cm.

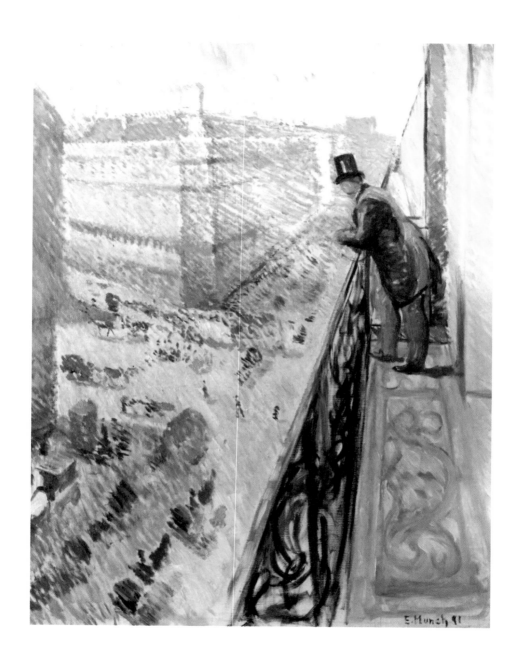

Rue Lafayette, 1891, oil on canvas, 92 × 73 cm.

FROM THE MODERN LIFE
OF THE SOUL (1890–1900)

PARIS TOWARDS THE END OF THE 1800S – the city of modernity. Spectacular roadways, department stores, shopping arcades and parks. Tall, uniform apartment buildings linked together in vast urban blocks. The city had recently undergone its most radical transformation ever – large areas of jumbled and haphazard small houses were torn down to make way for Georges-Eugène Haussmann's vision of the modern capital with its grid of long, wide boulevards. Many people lost their homes through this process, but it also brought about lighter, airier and healthier conditions. The water supply was improved and the risk of fire reduced. Traffic flowed more easily, and the various areas of the city were brought into closer contact with one another.

In *Rue Lafayette*, Edvard Munch explored his fascination with the modern capital.[1] Here, the city is seen from high above, with a dramatic perspective that cuts into the painting. The technique is shimmering and speckled, and it was during his time in the city between 1890 and 1892 that Munch painted his most impressionistic works. The relationship between the individual and the masses is emphasized in the contrast between the anonymous crowds moving down on the street and the man leaning over the balcony, an outside observer of the capital's spectacular dynam-

ics. But there is also something seemingly unstable about the situation. Is the railing solid enough to bear the figure's weight?

THE WORLD ON DISPLAY

Imagine arriving in Paris in the autumn of 1889 amidst the celebration of the centenary of the Storming of the Bastille and the start of the French Revolution. The anniversary was a measure of the Third Republic's (1870–1940) ideas about democracy, industrialization and liberal cultural life. An expansive world's fair topped off the festivities, featuring all that was cutting-edge within science, technology, art and culture. The world's tallest structure was also erected for the occasion: the Eiffel Tower. What could possibly be more modern than viewing the city from high up in the air?

As part of the tributes paid to the republic, a grand-scale presentation of the development of French art was established, going all the way back to the days of the revolution and spearheaded by a succession of renowned artists who, through the annual *Salon*, had transformed the city into the most prominent artistic metropolis of the day: David, Ingres, Géricault, Delacroix, Corot and Millet. Even outsiders such as Courbet and Manet were included. The impressionists, however, remained ostracized, but their paintings could be seen in the city's many galleries and exhibitions. Indeed, Munch had already seen their works in Paris, having spent a few weeks in the city in 1885 – but it was only now that he became truly familiar with the advanced modern art scene, led by the impressionists and their followers.

Until now, Rome had been the premier attraction for artists and authors, but during the 1800s other cities began to flourish as cultural magnets: Paris, London, Munich and Vienna. Like Rome, these cities could now also flaunt large museums and collections, but most important was what was happening there. In the new metropolises, an experimental, innovative modernism began to take shape – above all in Paris, the city that never

slept, the 'capital of the nineteenth century'. Paris became a meeting place that crossed national and cultural divides, and within the art scene strong, alternative movements developed in opposition to the academies and museums.

The fate of the *Salon* was a sign that change was afoot. Since the late 1600s, the *Salon de Paris* had been the most important event in contemporary art. Anyone could apply to be included, but few had their works accepted. There was quite a sensation when, in 1881, Norwegian artist Christian Skredsvig was awarded the gold medal for his painting *Une ferme à Venoix*. But the institution's status was in decline – younger, progressive artists viewed it as outdated, and from the year 1863 the alternative *Salons des Refusés* was held, based on the works rejected by the *Salon de Paris*. In 1884, the *Salon des Indépendants* was also established, in which anyone could participate – even amateurs. Munch, who preferred to see himself as among the new, radical artists, never participated in the *Salon*, but in the 1890s it became an important arena for him in France.

The art scene was changing, from an academy and salon-based system rooted in the state to a more open market where art dealers and critics attained greater importance. This happened in line with the growth of a well-off upper middle class. Dealing, private collecting and the commercial distribution of art were becoming increasingly popular, and an international network for advanced contemporary art came into being. This was important for the development of oppositional art movements at the turn of the century: the rise of the avant-garde.

THE SAINT-CLOUD MANIFESTO

Munch's stay in Paris did not go as planned. A condition of his scholarship was that he take his studies more seriously, and for a time he did so under the prescribed Léon Bonnat. But then Munch received word that his father had passed away suddenly; the funeral had already been held. To make matters worse, Munch then became ill himself, and so moved to the small

suburb of Saint-Cloud by the Seine, where he would write the closest he would ever come to a creative agenda – the so-called Saint-Cloud Manifesto, excerpted below:

> I was going to do something – begin [working on]
> something. It would grip others
> as I was gripped now.
> I would depict two [persons] in
> the most hallowed seconds of their lives –
> …
> In the instant one is no longer oneself –
> but merely one of the thousand generations –
> that propagates the next generation.
> …
> And the public will sense
> the sanctity of this – and they will
> take off their hats as in a church.
> …
> One shall no longer paint interiors,
> people reading and women knitting.
> They will be people who are alive, who breathe
> and feel, suffer and love.[2]

Munch's ambitions were laid out – the emotional sphere should be incorporated into art. Above all, the Manifesto is about confronting realism, and a desire for a more subjective, emotional art based on existential life experiences.

Munch wrote a lot during this period, mostly in a flowing, associative style that was in accordance with that of Hans Jæger and his notion of 'writing one's life'. To what extent Munch had authorial ambitions is unclear, but in the 1890s he seems to have gone through a literary or symbolistic period, and many writers were part of his circle.[3] In Saint-Cloud, he spent time with the Danish poet Emanuel Goldstein, and the Manifesto also had much in common with the attitudes of a young, rebellious author who had just attracted attention in Kristiania:

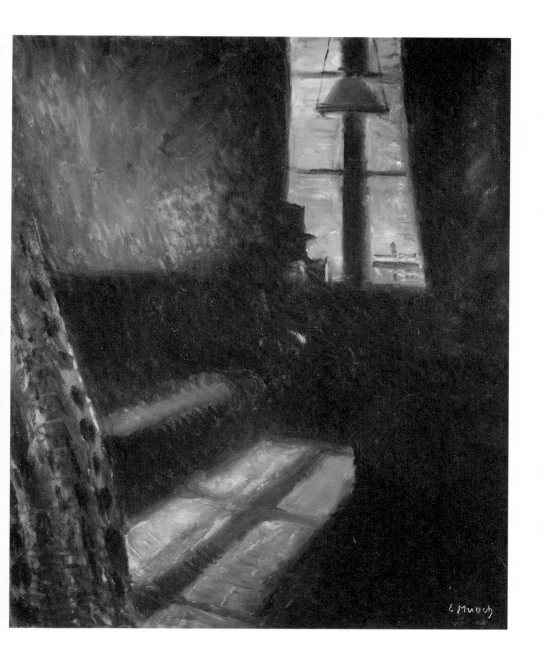

Night in Saint-Cloud, 1890, oil on canvas, 64.5 × 54 cm.

Knut Hamsun. Through articles and presentations, Hamsun raised the banner for art that dealt with 'the unconscious life of the mind' (1890). Munch and Hamsun sought to create art that went beyond realism and the current social debates – works that dealt with the subjective world of emotions and mental states.

Night in Saint-Cloud (page 61) shows how this became embodied in Munch's style, and the painting provides an introduction to his pivotal, symbolistic period. Different types of light appear as a central theme: the moonlight, the glow from a cigarette, the lantern of a boat seen through the window, and what might be a lighthouse on the other side of the river. Inside the room, in contrast to this, is an unlit paraffin lamp. New and old sources at odds with one another; the lamp of childhood extinguished beneath the moon's timeless glow. And inside the room, the diagonal lines of the window's shadow form a Latin cross – the Protestant church's foremost symbol of faith, hope, suffering and death. But there is also something else going on in this painting. The way in which the shapes dissolve or melt into each other, saturated sections giving way to diluted washes of colour. The swift technique with sweeping brushstrokes, and abstract elements such as the suggestion of a curtain in the foreground, are more consistent than in Munch's previous works. Somehow, the room seems to dematerialize. The bare canvas is visible in several places, which has a special effect. It is as if the painting is also lit from within, from the image itself. With works such as this, Munch contributed to the dawning symbolism within the art of the 1890s; to an anti-naturalistic impulse where dimensions beyond the visible and perceptible were put on the agenda.

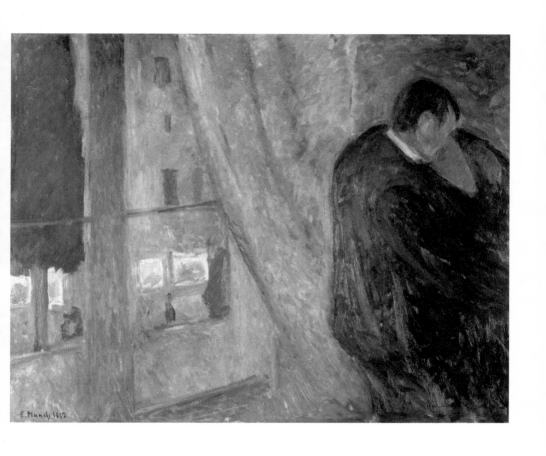

The Kiss, 1892, oil on canvas, 73 × 92 cm.

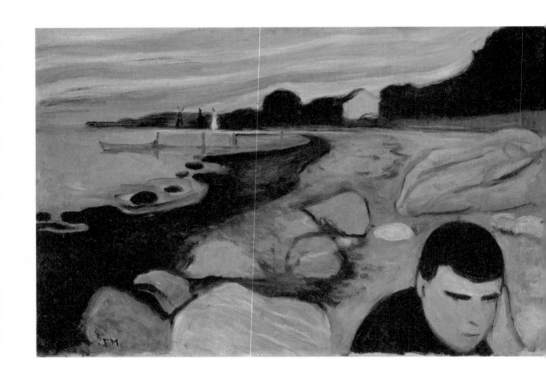

Melancholy, 1892, oil on canvas, 64 × 96 cm.

FROM *EVENING* TO *MELANCHOLY*

Another motif that Munch developed during this period first appeared under titles such as *Grief* and *Jealousy*, before finally becoming *Melancholy*. Like *Inger on the Beach*, painted two years earlier, this work depicts a figure in the foreground sitting opposite the sea, which has a fluid, curving shoreline. Munch now used the Åsgårdstrand shoreline as a suggestive element – a future recurrence. But the two paintings are different in both form and content. While the portrait of Munch's sister is executed with an emphasis on atmospheric mood, *Melancholy* bears a simplified symbolism. Its shapes are rougher, something most clearly evident in the sky's undulating forms; they create a sense of movement, pressure and rhythm. Everything is gathered into a stylized and psychologically charged whole.

The melancholy figure in the painting was based on a well-known thematic formula traditionally associated with the seven deadly sins; the condition of apathy and lack of initiative that leads to spiritual ruin. Munch's contemporary, the sculptor Auguste Rodin, reimagined this motif in his depictions of Hell. But for Munch the theme was extracted from its biblical roots, and instead connected to love and the human condition. Melancholy was now represented by an individual consumed by feelings of powerlessness regarding their surroundings and the realities of life.

The motif arose as a direct result of a specific situation within Munch's circle of friends, namely Jappe Nilssen's miserable love affair with Oda Krohg – both of whom were associated with the Kristiania Bohemians. In Munch's painting, the great gulf between the brooding, turned-away figure pressed right up against us and the distant people on the jetty creates dramatic tension, while at the same time the figures might be products of the thinker's imagination, like a kind of thought bubble. An old motif is reformulated, and given new meaning.

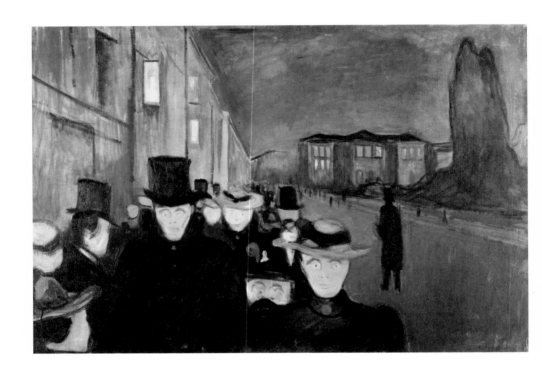

Evening on Karl Johan, 1892, oil on canvas, 84.5 × 121 cm.

BACK ON KARL JOHAN

Munch's inclination towards the emotional rather than the rational is evident in the paintings in which he returned to Kristiania's main street, including *Evening on Karl Johan*. In this painting, the viewpoint is now from among the crowd; the airy atmosphere of *Spring Day on Karl Johan* (page 27) has been replaced with an oppressive dusk through which people stream towards us, thick and fast, with disturbing faces. Both paintings emphasize the relationship between the individual and the masses through the depiction of a figure contemplating the scene. In *Evening on Karl Johan*, pale faces are illuminated as if by the glare of a flash bulb. Both paintings examine life outdoors in the city, with people in motion, but in the later painting the former spring idyll is replaced by something more anxiety-inducing.

The strange light in *Evening on Karl Johan* can be ascribed to the fact that electric streetlamps were introduced to Kristiania around the year 1890.[4] In Munch's painting, it is precisely the light that is emphasized, reflected in open windows and the Storting lit from within in the background. The way in which Munch expressed this phenomenon visually testifies to his curiosity towards contemporary innovations, and a willingness to feature them in his works.

THE SCREAM

It was around this time that Munch developed the image that would become *The Scream*.[5] The swirling, open-mouthed figure with its hands over its ears has become a world-famous celebrity, living a life independent of its artist and painting, reused and parodied in countless contexts. The figure is easy to caricature because it contains elements of caricature within itself. It has become an icon – a symbol of human vulnerability and the inner life of the soul.

Munch's development of the motif contains a critical moment. To begin with, he worked on a contemplative figure – a man turned away from the viewer, looking out across a land-

scape. This was a popular motif among the romantics of the early 1800s: an individual confronting the overwhelming power of nature. But then Munch turned the figure around, pulling it into the foreground to face us, and so we encounter the figure eye to eye, frontally and directly. In the background, two people disappear off into a landscape in motion, with an undulating, blood-red sky. The painting's portrait format is emphasized; the railings in the image are dramatized, the colours rendered more intensely. This is no longer a romantic depiction of mood, but rather the visualization of something entirely new – the thematization of an internal state.

Many years later, Munch composed a text about the background to the motif:

One Evening I was walking along a Hillside road
near Kristiania –
together with two Friends
It was a Time when Life had lacerated my Soul –
The Sun went down – had ducked in fiery retreat
beneath the Horizon –
– It was as though a Flaming Sword
of Blood slashed across the Vault of the Sky

The Air turned to Blood –
with glaring threads of Fire –
The Hills turned a deep blue –
the Fjord – glared in cold blue –
yellow and red Colours –
A shrill blood red[6]

The Scream captures this subjective experience of colour and movement. In a later, more developed version of the painting, from around 1910, the shapes are further abstracted into swirling movements and the colours even bolder, as described in the text. But the motif is still anchored in something seen and studied. From the eastern side of the fjord, we look across

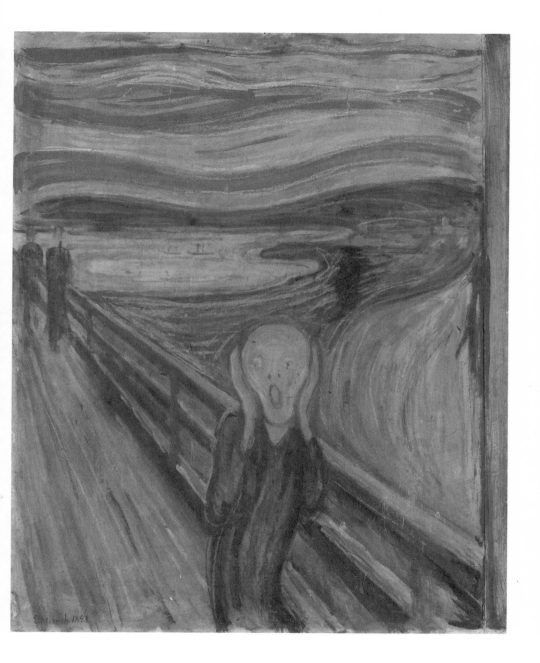

The Scream, 1893, tempera and crayon on board, 91 × 73.5 cm.

towards Kristiania; the view can be recognized as that from a popular location on a hilltop on the outskirts of the city. The era's postcard photographers often took the views from this spot as their subject, but Munch abstracted the elements, amplifying the subjectively experienced impact of the painting's overall effect. The landscape underscores the figure's mental state: inner and outer life are presented in relation to one another. One of the painting's first interpreters, Munch's bohemian friend and author Stanisław Przybyszewski,[7] described the work as a part of Munch's 'psychic naturalism' – a true portrayal of inner reality. Some of the strength in Munch's artistry comes from the fact that he did not make a definitive distinction between observation and depiction; between concrete reality and subjective experience.

Part of The Scream motif's durability has its roots in the fact that it appears to be deeply original. Indeed, a considerable number of screaming figures had been formulated before Munch began work on what would become his most famous motif – from prehistoric figures and antiquity's celebrated Laocoön sculpture, to Jesus and his cries of pain on the cross: 'My God, my God, why have you forsaken me?' In Munch's case, however, the scream's specific purpose or provocation is toned down, leaving interpretation of the image fairly open, and the motif offers some peculiar contrasts and ambiguities. The relationship between sound and its absence is emphasized by the echo-like linear interplay. Is the figure screaming? Or does it not want to hear? Is it a man or a woman? Young or old? What is the cause of the scream? The motif's familiarity and the many questions it posits invite us to respond. The painting becomes a mirror, through which the work's meaning arises in the encounter with each individual viewer.

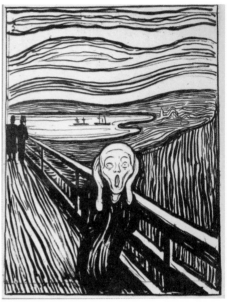

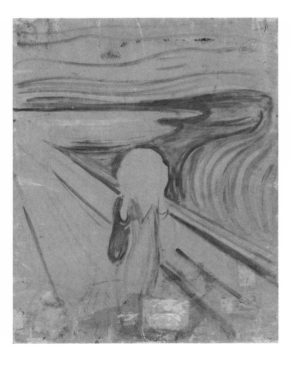

Despair, 1892, charcoal and oil on paper, 37 × 42.3 cm.

The Scream, 1895, lithograph, 35.5 × 25.4 cm.

The first attempt? The back of the National Museum of Oslo's version of *The Scream* from 1893.

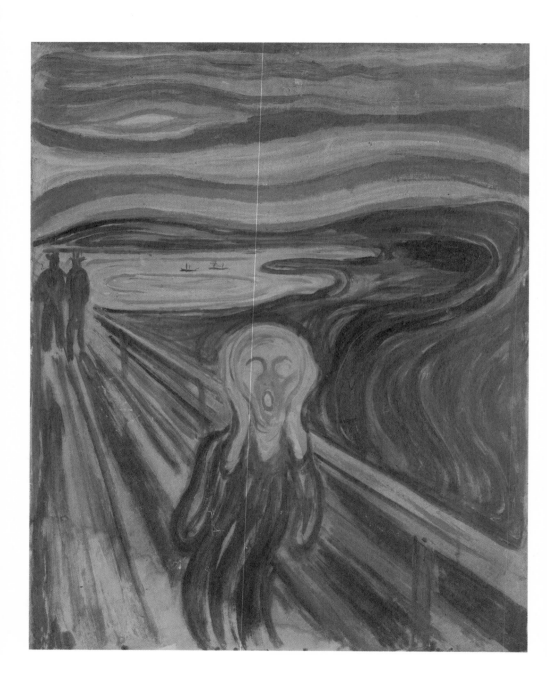

The Scream, c. 1910, tempera and oil on board, 83.5 × 66 cm.

MADONNA

Emotions also play a part in the motif originally titled *Loving Woman* (overleaf), but here they relate to desire, sex and conception.[8] At first, the image seems to be a straightforward depiction of a woman's sexual rapture, as it appears to her lover. A characteristic male depiction, one might say, created for a public and a market dominated by the heterosexual male gaze.

Imagine how sensational and brazen it must have seemed to depict female nakedness and sexuality in this way over a hundred years ago – directly, and for no moral, pedagogical or religious reason. The hands are placed behind the back, in order to draw attention to the woman's breasts, hips and stomach; her long, loose hair flows free as a sign of female abandon and erotic display. If the woman here is to be understood as the Madonna, the Virgin Mary, then she certainly seems to be in touch with the Holy Spirit! In some lithographic versions, Munch suggestively took the theme in the direction of impregnation, with the addition of a blood-red border containing swimming sperm cells and a foetus.[9] Once again, Munch's interest in new contemporary visual phenomena – and a willingness to use them actively in his works – is evident here. Only with the development of the microscope around the year 1890 was it possible to see what sperm actually consists of, and what it looks like in detail.[10]

Here, too, ambiguities arise. We are presented with a vision, but in a highly physical form. The naked woman abandons herself to us against a bed of fluid, watery shapes – but is she standing up or lying down? In ecstasy or in pain? Mentally present or absent? Or perhaps she might be a *femme fatale*, a figure that intrigued many artists of the 1890s – the attractive woman who uses her erotic magnetism to lead men to their destruction.

A secularized, eroticized Madonna. The connection to something exalted is strengthened by the figure's quiet majesty, and the red hairband that forms a halo around her head. But the motif also points to another woman from the Bible: Eve, after the Fall. Two opposites brought together in a single figure:

the pure, loving, innocent ideal and the sly, sensual figure of destruction. The painting is about male depictions of women, as they developed throughout the 1800s. The Virgin Mary and Eve came to represent a contrasting couple, speaking to notions of gender in which the man and woman were each other's opposites. The man who became most famous for this thematization was Sigmund Freud, with his depiction of women as either Madonna or whore.[11] But a significant feature of Munch's figure is that the woman is presented as holy in her sinfulness – a radical move, because it equalized traditional opposites. This woman refuses to neatly conform to defined categories.

In other works, Munch dramatizes the adult, heterosexual man's desire for the young female body. The perspective becomes more critical and exposing in works such as *The Hands* and *The Alley* (overleaf), in which a young, naked woman is surrounded by groping hands, or stands between rows of well-dressed men in suits. These images are conspicuously direct thematizations of unwanted sexual attention in the relationship between powerful older men and younger, socially vulnerable women. This is a theme that developed from the Kristiania Bohemians' interest in gender and free love, and particularly from Krohg's descriptions of Albertine, the poor girl used by men in power and forced into prostitution. In Munch's painting, however, the theme is formulated more generically.

SCANDAL IN BERLIN

Munch's many stays in France throughout the 1890s were each fairly brief, and it would be some time before he began to exhibit his works there to any significant extent. Instead, Berlin became Munch's continental home away from home. He garnered attention in the city, and settled here for a longer period of time. It was primarily during his stay in the German capital that Munch began to attain true significance on the contemporary international art scene, and it was also in Berlin that he would later experience his greatest successes.

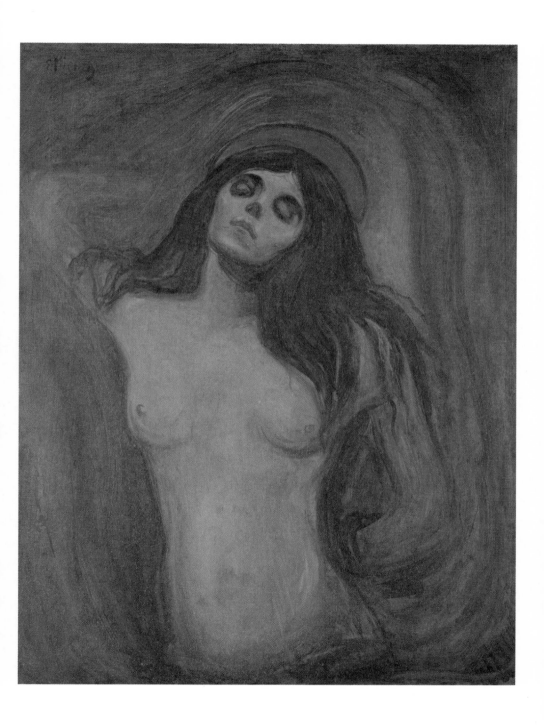

Madonna, 1894, oil on canvas, 90 × 68.5 cm.

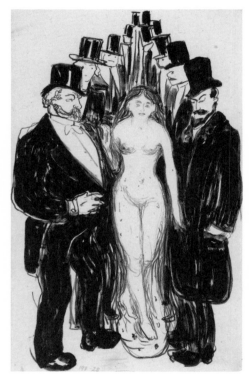

The Hands, 1895, lithograph, 48.5 × 29.6 cm. *The Alley,* 1895, lithograph, 43.5 × 27 cm.

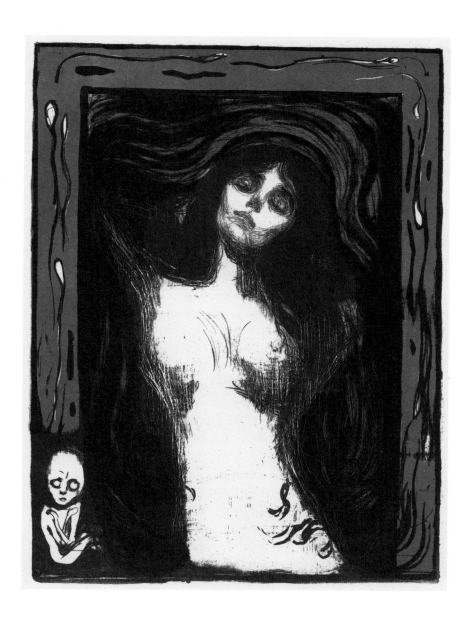

Madonna, 1895/1902, lithograph, 60.5 × 44.7 cm.

It all started with a sensational exhibition in the autumn of 1892. An older colleague of Munch's from Norway, Adelsteen Normann, was a member of the city's Artists' Association and arranged a large-scale presentation of Munch's works at the association's premises. The exhibition provoked much controversy – Munch's paintings caused widespread offence, even deep within the artists' ranks. Critics not only slaughtered the paintings with their harsh words, but also accused the association's board of having shown poor aesthetic and moral judgment in staging the show at all. The images were deemed incomprehensible, indecent and slovenly. But they were also subversive – scornful of the very definition of art itself, unfinished, shapeless, and with crazy, wild colours. The exhibition caused a deep rift among the artists – some defended it, while others felt it was unconscionable and called for it to be cancelled. Just five days after the exhibition had opened, the association's board decided to close it – an extremely unusual action taken 'with the greatest esteem for art and honest artistic aspirations'.[12] The exhibition was so provocative because it challenged the traditional understanding of the essence of art – what art was, and what it should be. In Berlin, Munch became the pioneer of a new, modern definition of art. That his paintings seemed sloppy and unfinished was one thing – but they also challenged the idea that art should be morally edifying and culturally enlightening, and thus have a refining effect on the viewer. Instead, Munch's images depicted life as lived by human beings. In the wake of the controversy surrounding the exhibition some artists broke away from the association, and in 1898 a new institution for the most advanced art of the age was established: the Berlin Secession.

Munch didn't take the cancellation of his debut in Berlin particularly hard – in one fell swoop he'd established his reputation as a free-thinking rebel, and causing such a scandal accorded well with the bohemians' ideals. Perhaps it might even pay off financially? Munch was at least able to mollify his aunt Karen in a letter home: 'I could have had no better

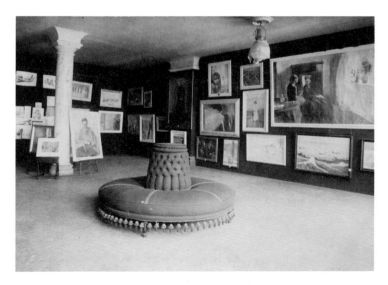

Munch's exhibition in the Equitable Palast in Berlin, 1892.

publicity – however I have made a great mistake – that I did not exhibit the paintings here in the city just after the closure, I would have earned many thousands of kroner....Incredible that something as innocent as painting can cause such a furore.'[13] This mistake was soon rectified, however – Munch exhibited his paintings again some weeks later, at the Equitable Palast. The following year, he held yet another exhibition, this time in rented premises on the city's main thoroughfare, Unter den Linden. This exhibition featured many new paintings, such as *Vampire, Death in the Sickroom* and *The Scream* – the latter under the title *Despair*.

Munch acquired a preference for exhibiting his works in this way: densely collated, in situations where he didn't need to share wall space with others. The paintings enhanced one another, and he was able to charge an entry fee – an important income for him, as he had not yet sold a painting for any substantial sum. In other words, it was a good thing that his exhibitions attracted such heated debate, becoming a 'succès de scandale'.

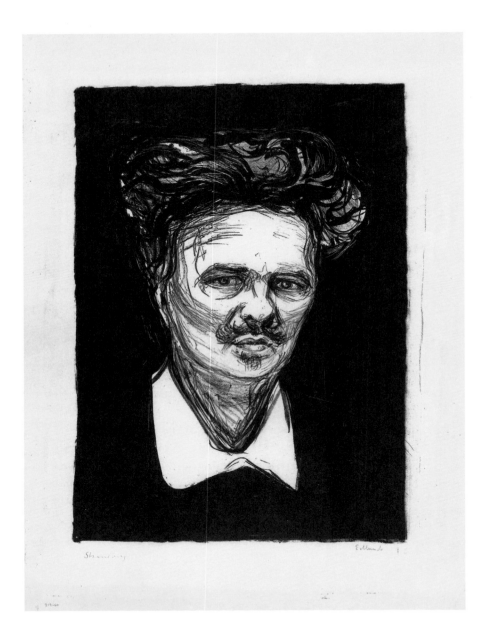

August Strindberg, 1896, lithograph, 61 × 46 cm.

Stanisław Przybyszewski, 1895, oil and tempera on board, 62.5 × 55.5 cm.

Dagny Juel Przybyszewska, 1893, oil on canvas, 149 × 100.5 cm.

Dance of Life, 1899–1900, oil on canvas, 125 × 191 cm.

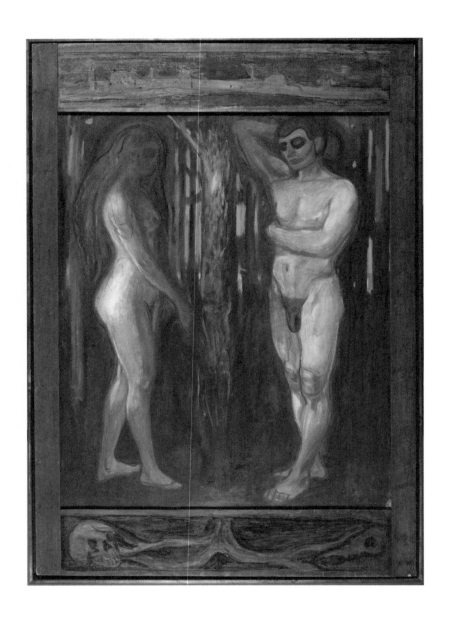

Metabolism. Life and Death, 1898–99, oil on canvas, 172.5 × 142 cm.

THE BERLIN BOHEMIANS

Munch preferred Berlin to Paris during these years for good reason – not only had he attracted attention in the city, but he was also more confident in the German language than French. He became part of a progressive bohemian scene, a circle of intellectuals who frequented a tavern known as *Zum schwarzen Ferkel* (The Black Piglet).[14] Music, literature, philosophy and art were both discussed and practised by strong personalities with radical convictions. The development of the telescope and microscope had opened a window onto new and previously unknown aspects of existence – it was now possible to study anything from outer space to the life growing inside a pregnant woman's belly. The controversial, recently divorced Swedish author August Strindberg led the way – an intellectual artist interested in anything and everything. Among the individuals who became important to Munch were the previously mentioned Stanisław Przybyszewski, Dagny Juel and Julius Meier-Graefe. Przybyszewski was a musically gifted writer who was interested in the works of philosophers such as Friedrich Nietzsche, and so deeply interested in Munch's paintings that he authored the first book about Munch and his works.[15] Meier-Graefe was a publisher who introduced Munch to his art and literary periodical *Pan*, and hired him to create a portfolio of graphics. A decade later, Meier-Graefe also praised Munch in his comprehensive survey of modern art after the impressionists.[16]

THE FRIEZE OF LIFE

Several of the paintings that Munch exhibited at his first exhibitions in Berlin would become connected to what he would later refer to as *The Frieze of Life* (*Livfrisen*).[17] All of them were stylized in form – frontal, emotionally intense and existentially charged: *Summer Night. The Voice, The Kiss, Madonna, Vampire, Melancholy, The Scream*. As the 1890s progressed, Munch had the growing sense that these very different images belonged together. They were displayed under collective titles such as 'Study for a Series: Love' (1893), 'Paintings of Life' (1902) and 'Motifs from the Modern Life of the Soul' (1904); later, they would become *The Frieze of Life*. Munch wrote of the connection between the paintings:

> The Frieze is intended as a number of decorative pictures, which together would represent an image of life. The sinuous shoreline weaves through them all, beyond it is the ocean, which is in constant motion, and beneath the treetops multifarious life unfolds with all of its joys and sorrows.

Munch developed the theme of death further with *Death in the Sickroom* and *The Smell of Death*. The works all stand independently, but if we look at them as part of a larger series, they appear to present a kind of narrative with a beginning, middle and end. From the first blossoming of love and erotic awakening to intimacy, desire and devotion; then into strife, ambivalence and conflict; and finally on to separation and death.[18] The series also unites some monumental compositions of a more allegorical nature: *Dance of Life* (page 83) and *Metabolism* (page 84). These images thematize the cycle of life, either through the woman at various life stages, or the notion of metabolism: through substances and materials that arise, are exchanged and perish, death and decomposition are seen as a prerequisite for new life. The fact that these paintings are anchored in a historically specific worldview is clear, as in the

latter's obvious references to the Fall of Adam and Eve. Munch often selected motifs, themes and symbols from a religious tradition and transformed them for use in a secular, worldly setting. The positioning of the works as items in a larger series became most evident at two exhibitions held in Germany, in 1902 and 1903. Here, a selection of the paintings were hung high on the wall, individually unframed but surrounded by a horizontal field linking them to one another, like a frieze. The exhibition space, the connections between the works and the integrated effect were of great importance.

There is something new at stake in these paintings. Love, desire and the relationship between man and woman had naturally been explored in art for many centuries, albeit anchored in biblical themes or mythological narratives. Munch toned this connection down, although traces of it remain evident in his use of titles, motifs and symbols. He was not the only artist to depict love's circumstances in this way – but of all his contemporaries, he may have been the artist who portrayed these circumstances most directly, in the greatest detail, and in the largest format.

In many of the images, one or two figures are situated close to the viewer in the foreground, against a backdrop of surroundings that support the painting's theme. The use of ambiguous motifs and symbolic forms recurs; a loving embrace might become something disturbing, as in *Vampire*, where a woman puts her arms around the figure of a kneeling man. Devotion and pain become indistinguishable. Is she kissing his neck, or sucking the life from him? Is she a *femme fatale*? Or is she providing him with nourishment? Against the wall behind them grows a partial motif we recognize from previous works: the suggestive shadow.

Hanging the Frieze of Life, 1902, pen, 11 × 16.4 cm.
The Frieze of Life, 1919, front cover to the exhibition catalogue.

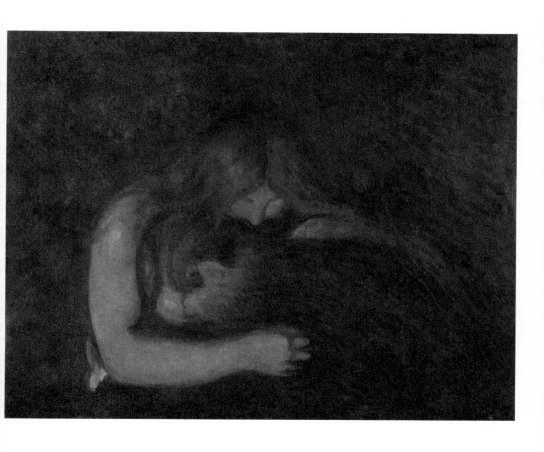

Vampire, 1893, oil on canvas, 77 × 98 cm.

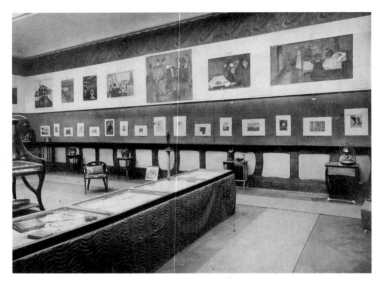

Munch's exhibition at P. H. Beyer & Sohn in Leipzig, 1903.

SELF-UNDERSTANDING

How was Munch's understanding of himself as an artist manifested in his paintings? Works such as *Self-Portrait with Cigarette*, *Death in the Sickroom* and *Blossom of Pain* may give us an indication. In *Self-Portrait with Cigarette* (overleaf) Munch is lit from below, almost like an artist on a stage.[19] The light hits his hand and face, while his upper body gradually disappears or dissolves into a painterly drama. The finely executed face stands out against the background's rapid brushstrokes, thin, hazy colours and running paint. This is one of Munch's most process-oriented works, a characteristic 'turpentine painting'.[20] Through the paint, the pale canvas creates a shimmering effect that amplifies the scenic impact.

The smouldering cigarette is placed strategically in Munch's painting hand, over the heart – the organ that from now on would serve as the primary source of creativity. Through the cigarette, Munch stages himself as an urban artist associated

with the age's anti-bourgeois bohemian lifestyle; someone who lives differently, on the sidelines of society. The gaze is direct, but still doesn't quite meet ours. He is looking slightly past us, towards something behind us. He sees something beyond our comprehension.

The direction of the gaze, and who sees what, is also a theme in *Death in the Sickroom* (page 94), Munch's most monumental depiction of loss within a family. Munch's preoccupation with illness and death is often linked to his experiences at a young age, but in the so-called 'decadence culture' of the 1890s these themes were common. Here, the situation is located within the intimate sphere, and the figures are barely distinguishable from Munch's own family. Along with the doctor/father figure, they are scattered around the patient, who is positioned far to the rear of the pictorial space. But they are all turned away from the dying person: on their way out of the room, turned towards us, lost in their own thoughts or in prayer – all except for the young man towards the centre, a figure not unlike Munch himself. In contrast to the others, he is looking directly at the person who is ill – right at the core of the situation. As in *Self-Portrait with Cigarette*, the artist is presented as a seer or visionary – someone who confronts the realities and significance of events as they occur. Within this lies the seed of an artistic agenda – to depict life as lived, with its entire spectrum of emotions, experiences and challenges.

Death in the Sickroom employs a different style of execution from the self-portrait: large, solid areas of colour, a perspective that draws the viewer in, and a dry, chalk-like surface. The effect is reminiscent of a fresco, where watercolours are applied directly to wet plaster and soak into the plaster mix. These differences show that Munch was experimenting with various techniques, materials and methods to an ever-increasing extent – but motivated by his content. The way in which he allowed diluted colours to seep into the canvas of *Death in the Sickroom* is characteristic of this thoughtful approach. The paint has soaked into the canvas as something

fluid, dissolved; the execution of the painting itself conveys smell, moisture and bodily fluids involved in death and illness. The pale colours strengthen the theme's impact, as do details such as the shapeless duvet, the blood-red medicine bottle, and the chamber pot sticking out from under the sickbed.

Munch continually returned to the role of the artist, perhaps most obviously in the woodcut *Blossom of Pain* (page 95), which depicts a man writhing in agony, one hand held up to his heart, blood streaming from a wound. The blood flows down onto the soil, and from this grows a beautiful plant. Creativity is born of suffering; life and art are one. The task of the artist carries responsibility, and comes at a price:

> I do not believe in art which has not been forced into being by a man's compulsion to open his heart. All art like music must be created with one's lifeblood – art is one's lifeblood.[21]

The artist who creates out of personal suffering and self-imposed renunciation became a theme with many variations in Munch's oeuvre – and the very cornerstone of Munch's perception of himself as an artist.

A MODERNIST IMPULSE

Munch explored the painterly process like a language, and a striking feature of many of his works from this decade is how the process of creation is rendered visible. We can study how he applied and used colour, employing significantly thinned oil, clear brushstrokes and flecks and marks that draw attention to the image's material surface to create varying effects. The painting reveals how it came into being – we are pulled into the creative act. This is often most evident towards the outer edges, or in areas alongside the main motif. In paintings such as *Madonna* and *Self-Portrait with Cigarette*, the canvas shines through thin washes of paint. Munch's work with watercolours has obviously played an important role here,

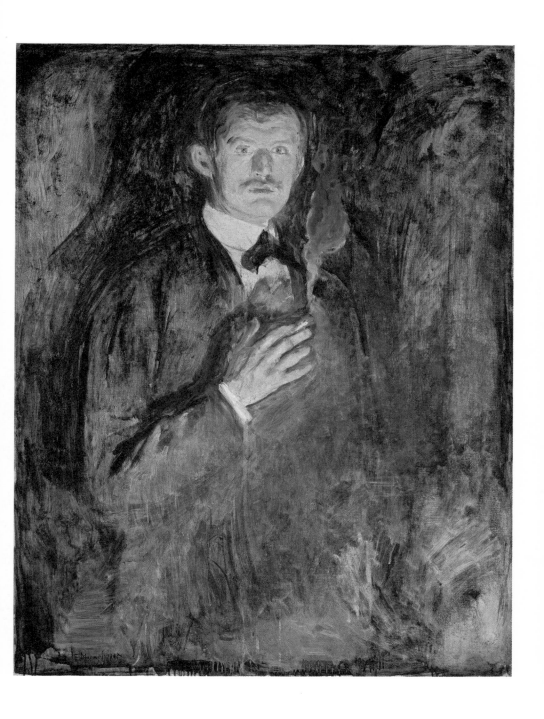

Self-Portrait with Cigarette, 1895, oil on canvas, 110.5 × 85.5 cm.

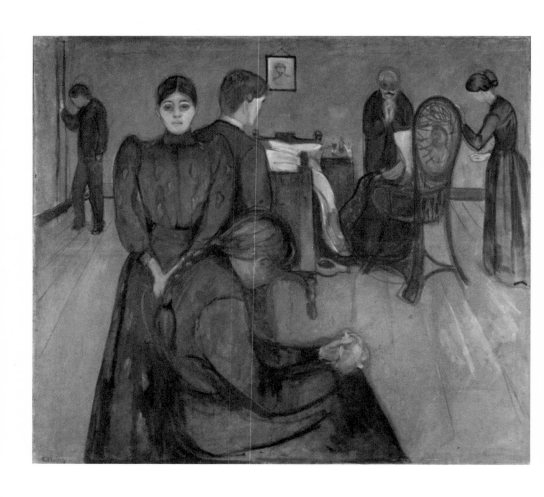

Death in the Sickroom, 1893, tempera and crayon on canvas, 152.5 × 169.5 cm.

Blossom of Pain, 1898, woodcut, 46.5 × 33 cm.

with his competence and experience in one medium being transferred to another. As we have seen, this creates special luminous effects, but these features also stress the image's status as a physical object. What the image depicts is thereby set in dialogue with what it actually is. The image that thematizes itself and its own objecthood would become central to the discussion about modernism, and Munch participated in modernism's self-critical impulse – but in his own way.[22] The emphasis on process, and the interplay between motif, materiality and 'means made visible' were aspects of Munch's practice that he developed further around the mid-1890s, when he began working with prints.

PRINTS

In Berlin, Munch encountered people who were interested in the opportunities offered by the graphic arts. Through various printmaking techniques, motifs could be reworked, duplicated and distributed on a large scale. To create prints of one's paintings was not common practice among artists at the time, but to the extent that it did happen, it usually took the form of reproductions that closely resembled the original. However, modernist painters such as Paul Gauguin and Henri de Toulouse-Lautrec began to produce more original works through printmaking – something that Munch also started to do. Although he saw himself primarily as a painter, Munch was open to the possibilities offered by other media and techniques: 'All means are equally appropriate.'[23] He would continue to work extensively with printmaking until the very end of his life, and became one of the twentieth century's foremost 'painters-turned-printmaker'.[24]

Munch quickly transformed many of his most important motifs into graphic versions, but not as simple reproductions. Generally, the images were given a new form, often dictated by the unique requirements and characteristics of the relevant technique.

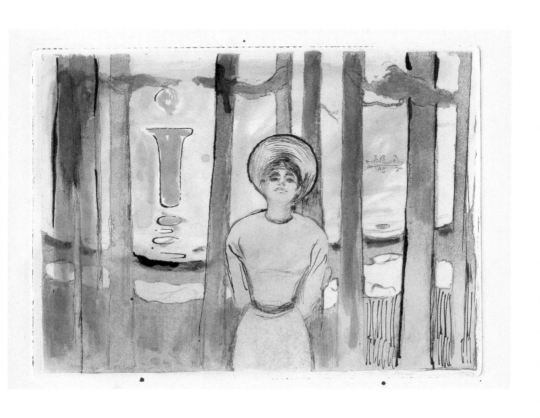

Summer Night. The Voice, 1894, etching, 24.7 × 32 cm.

Take something as simple as a kiss – two people entwined in a flat, abstract shape. He bends towards her; their faces merge into each other's; they become one. Versions of *The Kiss* are among Munch's most well-known woodcuts, mainly due to the image's striking design, but also precisely because the works do not appear to be reproductions.[25] The growth rings of the wood-block are visible in the printed materials and emphasize what the image actually is: a *woodcut* – in some versions the lines run continuously across the entire surface. Woodcuts belong to the category of relief printing, in which ink is applied to the intact (uncut) areas of the block and then printed. This is especially evident in *The Kiss IV* (page 101), where the pattern of the wood interweaves elements of nature, time and love – the tree's slow life cycle entwines with the all-consuming, exalted moment.

As early as in *Summer Night. The Voice*, created as an etching in 1894, Munch was able to transfer a motif from painting to print in an original way. The motif seems to have matured, and the elements are brought into sharper focus: the woman by the water at the forest's edge; the reflection of the moon and shoreline; the boat with people out on the fjord. We get closer to the rustling of the trees, the sounds that cannot be heard. The reverse of woodcuts, in such intaglio printing ink is applied to the worked areas of the plate to form the image. In *Summer Night*, the features of the technique and opportunities for variation using fine nuances and hard contrasts, shading, lines, marks and impressions are all utilized to the full.

Later, copper plates would come to function as a kind of sketchpad for Munch. With lithography and woodcuts, he could work in larger formats – something that suited his most iconic images. He learned the techniques through experimentation. Lithography belongs to the category of flatbed printing, and involves a more complicated chemical-mechanical process, generally requiring collaboration with professional printers. At first, Munch had no knowledge within this field, but he sought out the most eminent master printers in Paris and Berlin, and learned from them.

In his woodcuts, Munch refined his technique so that he was able to vary the image's appearance and increase the intensity of the colours. He cut the woodblock into pieces, so that different colours could be applied to the various parts of the motif before it was reassembled, like a jigsaw puzzle. Several colours could therefore be printed side by side, instead of layer by layer. A significant advantage of this was that the plate could be put together in several combinations. *Two Human Beings. The Lonely Ones* (page 103) was created in this way, in many variations. The technique was also well-suited to depictions of landscapes, which could be imbued with an atmosphere charged with something bound to nature, or eroticized shapes. In *Mystical Shore* (page 102), the wooden plate's organic lines merge into a phallus-like reflection of the moonlight on the water's surface, and a round tree stump.

Self-Portrait with Skeleton Arm (page 105) and *August Strindberg* (page 80) introduce an extensive series of lithographic portraits. Munch continued to pursue his interest in the artist portrait, but now confined to the face – the mirror of the soul. By combining various tools and techniques, such as chalk, ink and engraving, a liveliness and movement arose in the interpretation of the sitter. Together with the later *The Brooch. Eva Mudocci* (page 104), the images portray several of the most famous faces from these years in Berlin. Even when transferring the motif of *The Sick Child* to lithography (page 107), Munch zoomed in on the girl's pale head and face. The work became the most complex he created as a lithograph, with as many as six different layers.

One of Munch's distinguishing features as a graphic artist was his interest in making multiple versions of his motifs, often incorporating visually arresting faults arising from the technical process in the final products. He continuously returned to the same motifs, often with evident traces of carelessness and wear and tear, or misaligned layers of colour, as in *Moonlight by the Sea* (page 106). The contours of the lithographic stone's uneven outer edges might be visible in the final print, atop which Munch sometimes also worked with watercolours.

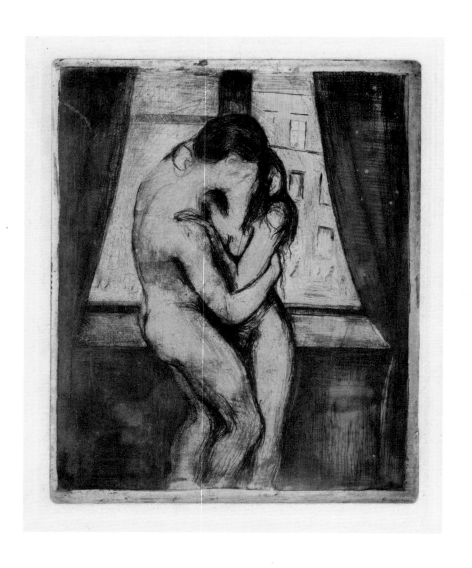

The Kiss, 1895, etching, 34.5 × 27.8 cm.

The Kiss IV, 1902, woodcut, 47.1 × 47.8 cm.

Mystical Shore, 1897, woodcut, 37.2 × 57.2 cm.

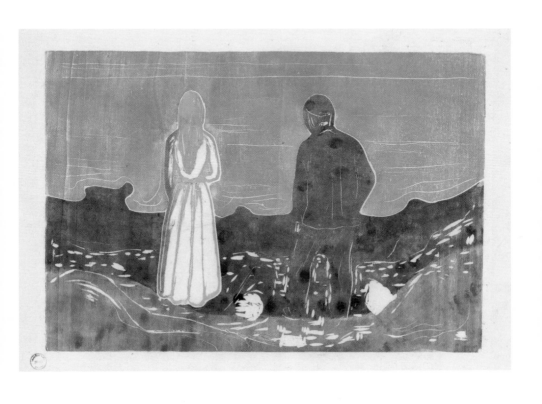

Two Human Beings. The Lonely Ones, 1899, woodcut, 39.6 × 55.5 cm.

The Brooch. Eva Mudocci, 1903, lithograph, 60 × 46 cm.

Self-Portrait with Skeleton Arm, 1895, lithograph, 46.2 × 32.4 cm.

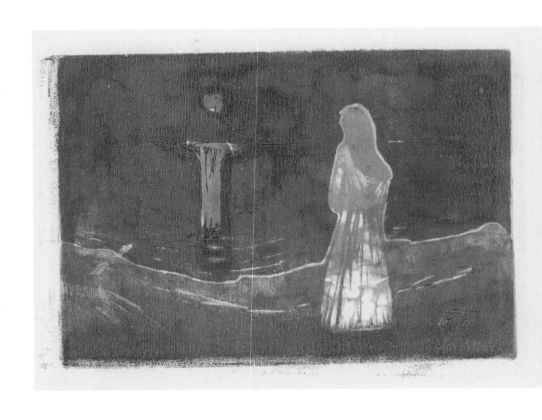

Moonlight by the Sea, 1912, woodcut, 18.6 × 26 cm.

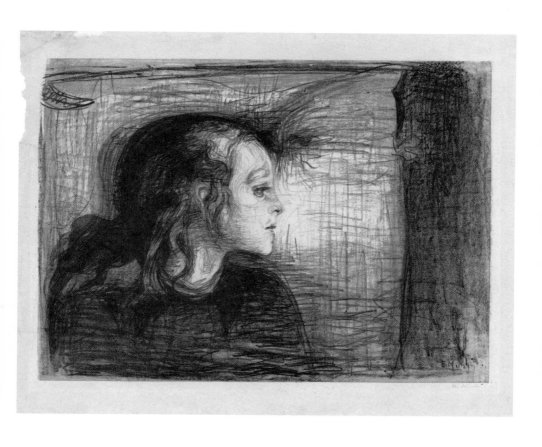

The Sick Child, 1896, lithograph, 43 × 58 cm.

Kiss in the Field, 1943, woodcut, 40.5 × 49 cm.

What attracted Munch to the graphic arts? To start with, he was probably motivated by the opportunities to sell his art and network with other artists, but it would be several years before he actually made any significant sales. After some time, however, Munch's works began to attract interest from experts such as Gustav Schiefler in Hamburg, who prepared a two-volume publication of all Munch's graphic works.[26] The medium also provided new ways of working – with printmaking, for example, it was possible to preserve the various stages of the process through an image, whereas with painting, drawing and sculpture, the interim stages are always more or less lost. As we have seen, the loss of the first, immediate image, and the challenge of later recovering it, was the crucial experience Munch gained from his work with *The Sick Child* in 1885–86. With graphics, on the other hand, he was able to print and change the image without the previous versions being lost. As time went on, Munch would come to use the potential inherent in the medium to highlight the characteristics of the technique in the work's creation and further development.

The Kiss was among the motifs to which Munch most often returned, both as a painter and a graphic artist; the image became especially successful when he rendered it as a woodcut. Towards the very end of his life he gave the woodblock's growth rings and grain the starring role. In *Kiss in the Field*, the encircled couple disappear into their surroundings, dissolving into the material from which they are created. The work is perhaps Munch's most abstract or least processed print, an almost ready-made image. Munch's interactions with graphic techniques were inseparably linked to his wider oeuvre, but they also constitute a distinct chapter in his artistic development.

THE GIRLS ON THE BRIDGE

During the 1890s, Munch developed a distinctive style of landscape painting, often based on the area around Åsgårdstrand. The pale Nordic evening light would often dominate the image,

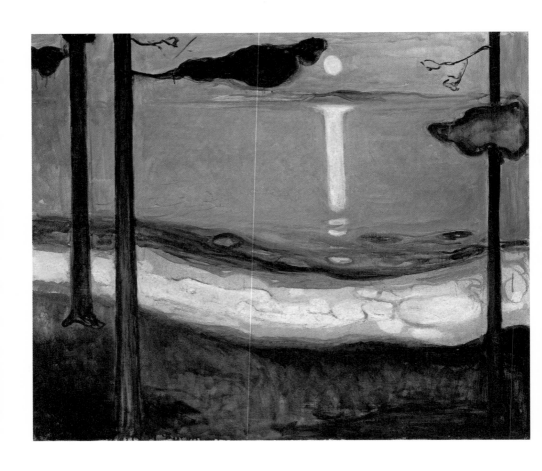

Moonlight, 1895, oil on canvas, 93 × 110 cm.

with a full moon reflected on the water and a curving shoreline. In line with the era's new romantic trends, these landscape paintings denote a more lyrical, atmospheric side to Munch as an artist – it is as if the romantics' small studies of nature and landscapes have been blown up to a larger scale. Poetic vistas characterized by stylized simplification, a nuanced play of colours and mysterious shapes – or Munch might combine the view with figures. Sometimes the landscape serves as a sounding board for a human drama, or sometimes the reverse, with the figures amplifying some aspect of the mood of the landscape. In other works, these aspects seem more inseparable and balanced, such as in the painting that would become Munch's most popular: *The Girls on the Bridge* (overleaf).

Munch developed this motif in Åsgårdstrand – the town's characteristic white houses and bridge are repeated in the many different versions he created. Dressed in white, red and green, the girls maintain their individuality within the group. The perspective draws the viewer into the image, and is amplified by the railing and a road that disappears off into the unknown. The girls are looking down into the water, turned away from us, as if in intimate conversation. What are they talking about? A majestic tree is reflected in the water's surface, a dark, suggestive shape broken only by the fluid shoreline. It is no coincidence that the girls are standing on a bridge, at the border or transition between one place and the next.[27] Again, this is a well-known motif. In Munch's works, the bridge often becomes a place where the relationships between the individual and the community, and the individual's fundamental life experiences, are articulated.

But *The Girls on the Bridge* is also a reformulation of a painting that Munch knew well from the National Gallery in Oslo: Erik Werenskiold's painting of two provincial girls in intimate conversation, leaning on a fence (*September*, 1883).[28] Here, too, the girls are on the cusp of womanhood. But in Munch's work, Werenskiold's daytime realism becomes dusk, with loose brushstrokes and a more psychologically charged drama.

The way in which the girls study the water's surface also actualizes another theme – that is, our position as observers. We stand and look at those who are standing and looking inside the painting. Various realities collide in a reflection on the mystery of the origin of the painting itself – on what it means to create and look at images.

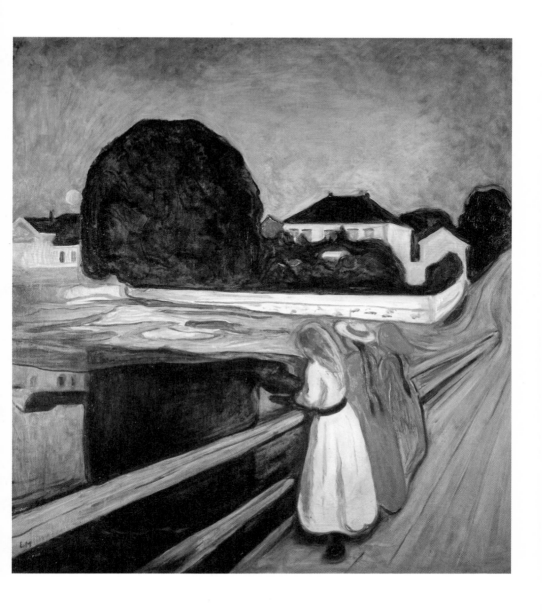

The Girls on the Bridge, 1901, oil on canvas, 136 × 125 cm.

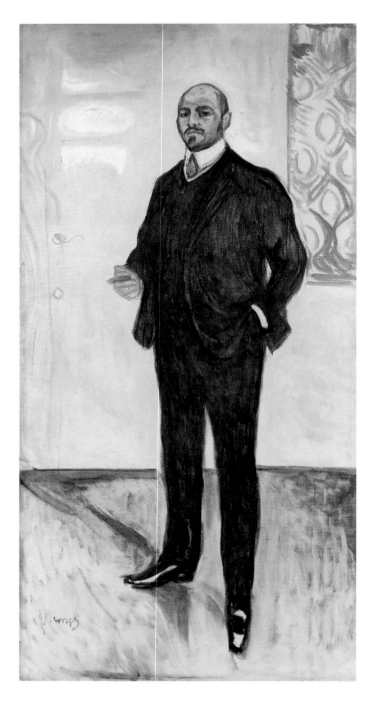

Walter Rathenau, 1907, oil on canvas, 220 × 110 cm.

THE ARTISTIC RENEWAL
(1900–1916)

THE EARLY YEARS OF THE 1900S heralded an interesting phase in Edvard Munch's work, dominated by two conditions: a close connection to the era's leading cultural activities on the continent, and a personal artistic renewal.[1] These conditions were, of course, related – but a desire to develop his artistic practice was not the sole reason that Munch came to spend so much time abroad in the first decade of the twentieth century, and especially in Germany. Munch had entered into an intimate but somewhat agonizing love affair with Tulla Larsen, a wealthy woman six years his junior. The relationship came to an end in the autumn of 1902, with a pistol shot in Åsgårdstrand – nobody was killed, but the incident had a profound effect on the artist.

The fact that Munch was already attempting something different in his paintings is evident in his use of brighter colours and stronger luminous effects and brushwork. But his subject matter also changed to include fertility and the harvest, powerful male bodies, stalwart workers, sparkling winter landscapes and the radiant sun. As previously, the subject was still often depicted frontally, in a straightforward manner and with reduced spatial depth. But the soft, curving linear interplay of the 1890s transitioned into a flatter,

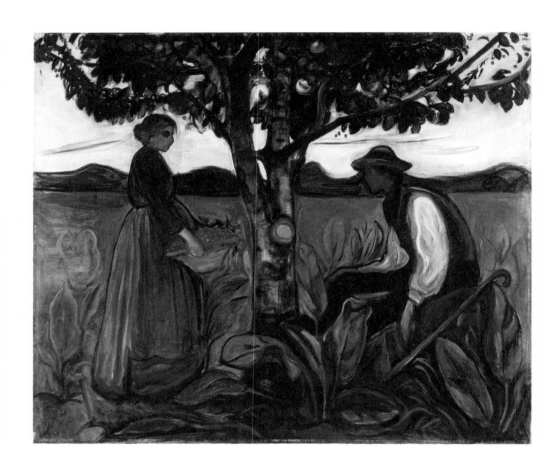

Fertility, 1899–1900, oil on canvas, 120 × 140 cm.

more systematic style of painting, with emphasis on abstract patterns and broad, parallel brushstrokes that gave a powerful, almost monumental, impact. This new direction is most evident in several large paintings of people bathing, which Munch created in 1907 and 1908, and reached its peak with the decoration of the Aula, the University of Oslo's ceremonial hall, completed in 1916.

THE GREAT PORTRAITS

Munch made many contacts in Germany. In addition to his friends and colleagues, he was now encountering individuals within a new stratum of society: successful leaders, directors and trendsetting initiators who bought his works and supported him. This started with industrial leaders and businessmen such as Walter Rathenau and Albert Kollmann; subsequently, the eye doctor and art collector Max Linde entered the scene.[2] Linde put Munch in touch with art dealer Paul Cassirer and graphic arts enthusiast Gustav Schiefler, who in turn introduced him to the Galerie Commeter in Hamburg. The ball was finally rolling.

Linde must have been extraordinarily engaged by Munch's works. He initially purchased the painting *Fertility*, and then commissioned portraits of his wife and children, a large portfolio of prints, and an entire frieze for his children's bedroom. The frieze would never be completed, but Linde continued to purchase Munch's art. He also proceeded to write a book about Munch – the first to be published in German since Przybyszewski's, in 1894.

In the wake of these connections, Munch produced a series of grand, full-length portraits of men, at almost life size (overleaf). The subjects are representatives of a modern, culturally conscious elite, a stratum of society to which Munch increasingly belonged and with which he increasingly identified: a group of outgoing, self-confident and worldly individuals. Together with his friends and relations from the Nordic

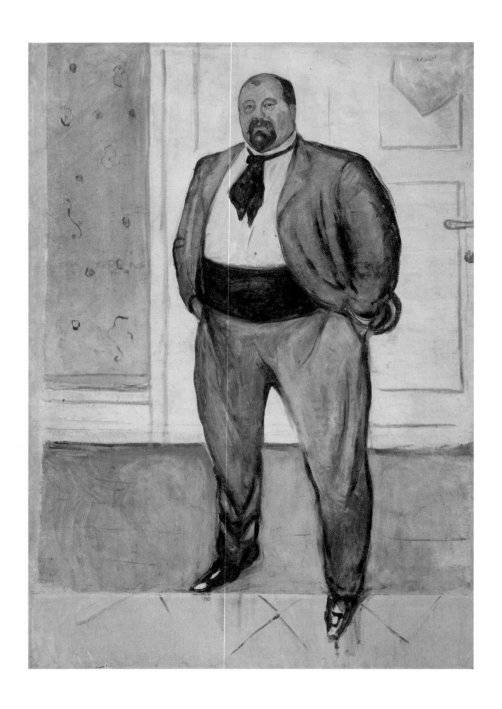

Consul Christen Sandberg, 1901, oil on canvas, 215 × 147 cm.

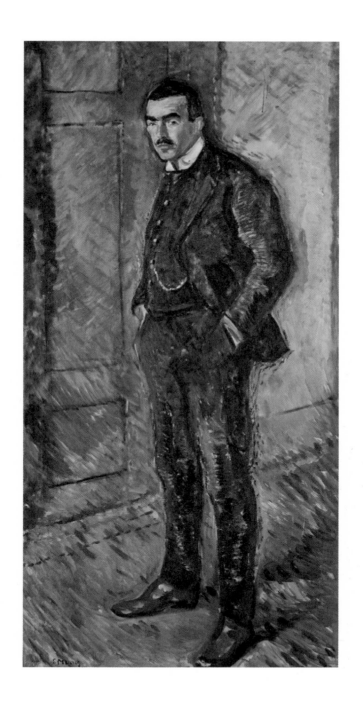

Jappe Nilssen, 1909, oil on canvas, 193 × 94.5 cm.

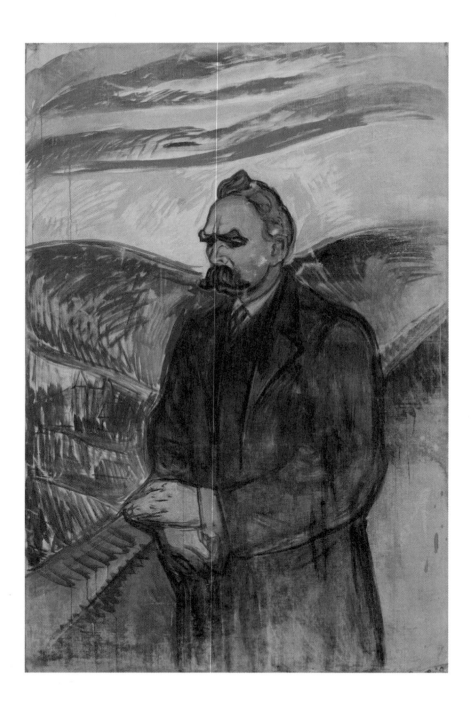

Friedrich Nietzsche, 1906, oil and tempera on canvas, 201 × 130 cm.

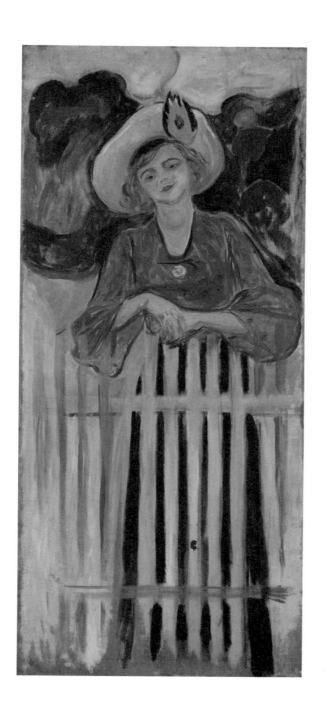

Ingse Vibe, 1903, oil on canvas, 160 × 70 cm.

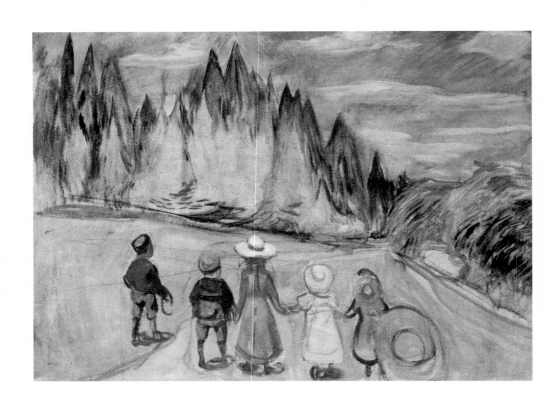

The Fairytale Forest, 1901–2, oil on canvas, 79 × 106.5 cm.

countries, the series also includes interpretations of a long line of collectors and supporters.

These 'great portraits' appear almost as variations on a common theme: frontal portrayals of figures against basic backgrounds, with just a few environmentally descriptive details. The long, narrow format of up to two metres in height establishes a close relationship between the figure, the painting, and the viewer – we are set on equal footing with the person portrayed. The general form remains the same, but the works exhibit significant variation in execution, from the thinly painted portrait of Christen Sandberg to the far lusher, crackling portrayal of Munch's friend Jappe Nilssen, in which a shower of colours and rhythmic brushstrokes rain down the image's surface.

The three-quarter portrait of Friedrich Nietzsche was created on commission, some years after the philosopher's death. In the painting he appears as a monolith, or primordial force – a visionary emphasized by an undulating, psychedelic landscape reminiscent of *The Scream*. Munch was in close contact with Nietzsche's circle in Weimar, and the philosopher's fascination with human drives – what compels the vigorous and strong-willed – obviously contributed to Munch's new direction.

Great men dominate Munch's portraits of this period, but his other works testify to the fact that he had in no way lost his interest in young, beautiful women following his affair with Tulla Larsen. The portraits of Eva Mudocci and Ingse Vibe manifest a deep sympathy with the women portrayed. The latter is depicted in a slightly coquettish, charming pose, wearing a light summer blouse, but standing at a safe distance behind a fence. This far, but no further.

Another side of Munch's artistic reorientation was a growing interest in depicting children. In *The Fairytale Forest*, the theme from *The Girls on the Bridge* is applied to the world of childhood: a row of children stand on the threshold of something unknown in the forest. Around this time, Munch created several group portraits in which he placed greater emphasis on the child's individuality and development, from infancy to adolescence.

STALWART PEOPLE

In 1907 and 1908, Munch spent much of his time in Warnemünde in the north of Germany – a sort of German version of Åsgård-strand.[3] The town facing the Baltic Sea served as a port for traders in Rostock, but in the summer it was invaded by well-to-do citizens seeking some time by the sea. The new railway meant that the region's enticing shoreline was just a short day trip from Berlin.

In Warnemünde, Munch produced some sensational full-figure paintings of men: vigorous male bodies bathed in scorching sunlight, either naked on the beach or in work clothes as part of city life. In *Bathing Men*, the figures appear to us strong-willed, robust and dynamic: naked, but self-assured and solid. They seem to be ordinary men, their faces tanned from a life spent being active outdoors.

The figures take up much of the pictorial field; it seems as if they are approaching us. Some step forward slightly demonstratively, their stances wide and genitals exposed, as if to emphasize their bodily presence. Their faces are anonymous; it is their bodies that 'speak', communicating a stalwart self-confidence. They are, in other words, a completely different kind of male figure from the bohemians of the 1890s. These men are physically healthy and well-built, but without any heroizing or idealizing traits.

Over the following years, Munch's interest in such solid, stalwart men was followed up with depictions of workers – mainly anonymous manual labourers such as cleaning women, craftsmen, foresters and factory employees. These were presented in the same head-on, frank style as the figures in *Bathing Men*, but now were stopped on the street, on breaks at their jobs, or caught on their way to or from work. Munch created paintings such as *Mason and Mechanic* and *The Worker and the Child* (overleaf) in Warnemünde, but the theme of the worker was as yet in its infancy – Munch would continue to develop it well into the 1930s.

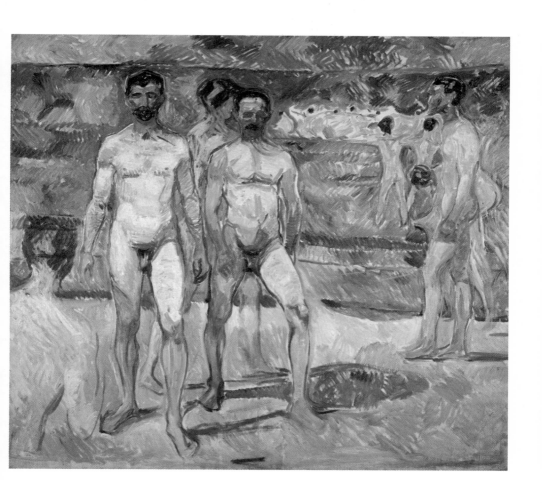

Bathing Men, 1907–8, oil on canvas, 206 × 227 cm.

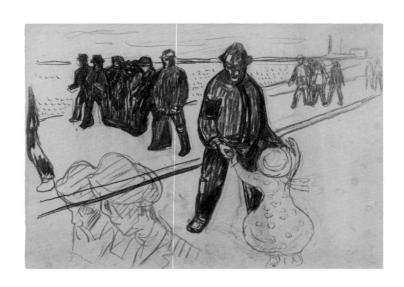

The Worker and the Child, 1907, charcoal, 55.8 × 79.5 cm.
Charwomen in a Corridor, 1906, gouache and charcoal, 71.5 × 47.5 cm.

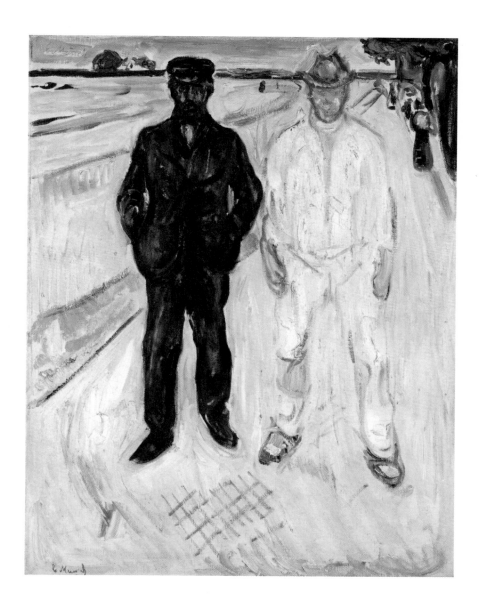

Mason and Mechanic, 1907–8, oil on canvas, 90 × 65.5 cm.

The naked, bathing male body was not a new subject for Munch in 1907, but his approach to it differed from his earlier works. One change was the paintings' monumental size – at over two metres in height, they were significantly larger than those he had produced to date. And while he had previously painted young boys in the water, these paintings depicted adult men exuding masculine strength and virility. The impact of light in the images was also significantly amplified; the use of colours intensified and the bodies given a more plastic form. With these paintings, Munch contributed to the age's vitalistic trends.

VITALISM

At the turn of the century a new interest in the healthy, vital and affirmative aspects of life began to take hold – what is today referred to as vitalism. The new trend stood in stark contrast to the decadent culture of the 1890s, which had been characterized by symbolic mysticism, romantic reveries and new religious influences. More broadly, we can understand vitalism as a reaction to the processes of modernization and secularization taking place throughout the 1800s, with the emergence of urban culture, modern lifestyles, technological innovations and alienation. To a certain extent, the trend was anti-modern in its emphasis on the fundamental life forces of nature, fertility and reproduction, but in its most explicit form the celebration of all that is creative and life-giving took the place of religion in understandings of life. As the term suggests, vitalism was not confined to a single style or group, but rather a cultural phenomenon linked to a new lifestyle, characterized by outdoor recreation, physical activity, sunbathing, and the pursuit of a healthy diet and healthy relationships. Growth, strength and reproduction were central themes, together with an interest in youth, potency and nudism, fresh air and sunshine.

THE DEATH OF MARAT

Naturally, however, not every subject was deemed equally edifying. The fact that Munch was exploring new ground during this period is perhaps most evident in paintings where the main theme of his works from the 1890s – the relationship between man and woman – is developed further. The scene was now set indoors, with figures arranged in a claustrophobic space, almost like scenographic tableaux or stills from a film. Some of the paintings were collated in a new series, *The Green Room*, while others took as their subject a dissection or murder motif. These experiments on the theme culminated in *The Death of Marat* (overleaf) – a painting almost unrecognizable as Munch's work. Loud shades of yellow-orange and green are surrounded by a shower of strong colours, and a systematic grid pattern of broad, long brushstrokes, applied perpendicular against horizontal, broke with his usual visual approach. The form of this work is so striking that at first the painting looks like a flickering screen. The execution seems just as important as what the image portrays: two naked individuals, a man lying on a bed and a woman standing, facing us. Clearly, some drama has unfolded here: the sheets are bloodied, and the man's arm hangs lifelessly from his side. It is unclear whether or not the man is dead, but in her obvious calm, the woman appears to be the perpetrator of the crime.

Why title the work *The Death of Marat*? Who are the players here? What does the murder of Jean-Paul Marat, a hero of the French Revolution, have to do with Munch's visual world around the year 1907? Munch rarely used such historical or mythological titles. Perhaps the hanging arm might give us a clue? Through the depiction of such a hanging arm, painter Jacques-Louis David had, in his time, presented Marat as a modern martyr. The arm linked Marat's revolutionary struggle and subsequent fate to the execution of Jesus – to images of Christ being taken down from the cross, or dying in the Virgin Mary's lap. The fact that Marat was murdered by a woman, Charlotte Corday, also made the subject piquant, and permitted

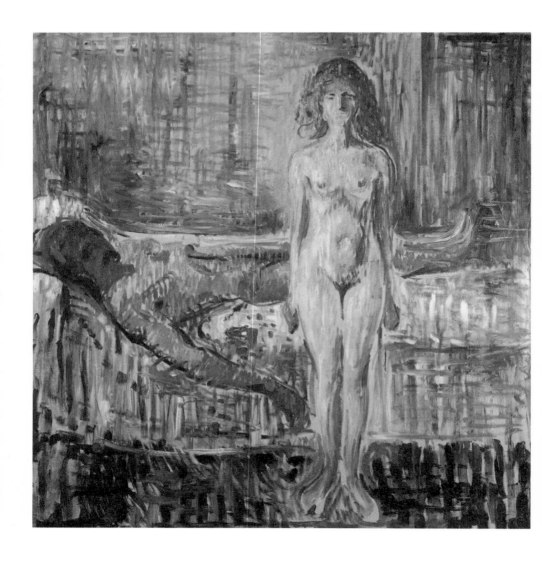

The Death of Marat, 1907, oil on canvas, 153 × 149 cm.

associations to the gunshot fired in Åsgårdstrand. In Munch's mind, Tulla Larsen had become an enemy who was out to get him – or worse yet, a real live *femme fatale*. They had met in the autumn of 1898, and developed a close relationship. But the affair quickly became steeped in jealousy, paranoia and heartbreak. The fact that Tulla Larsen was rich, while Munch was continuously in need of money, did nothing to help the situation, and everything came to a head in the autumn of 1902 – first with Larsen allegedly trying to take her own life, and then in an encounter between the pair at the house in Åsgårdstrand where an accidental gunshot injured Munch's left hand. With this, the relationship was finally over, and Larsen later went on to marry the artist Arne Kavli. But for Munch, the incident only exacerbated the growing paranoia that would culminate in a mental breakdown in 1908.

Like *The Sick Child* and several of Munch's other works, *The Death of Marat* invites biographical interpretation, but it is not a necessity that we understand the painting in this way. There are other relevant angles from which we might view the work. In a sense Munch was, like Marat, also actively contributing to a revolution, breaking with the great painterly tradition stemming from the Renaissance, and formulating a new kind of art. Munch participated in the struggle for modern art's recognition and development, and, tellingly, this revolution took place in the city where *The Death of Marat* was exhibited for the first time – in Paris, where the painting was displayed at the *Salon des Indépendants*.

Some years earlier, the leading members of the European art scene had been challenged by several young artists in Paris, who took breaking with tradition to yet another level – taking up the gauntlet first thrown down by Cézanne, Van Gogh, Gauguin and Munch. They painted with wild strokes of the brush and screaming colours, creating expansive landscapes with green shadows, peopled by vivid figures with blue hair. Their paintings were overtly anti-naturalistic, as if the paint was applied unmixed, straight from the tube. They were

referred to as wild animals – *Les fauves* – and their unifying leaders were Henri Matisse and André Derain.

Munch remained attentive to what was happening within the art world. To be of one's time was an ideal he had retained since his youth in Kristiania. Some of his strength as an artist comes from his receptivity to such changes in the sensibilities of the age, combined with his ability to make use of these impulses without compromising his own standpoint.

SNOW-COVERED LANDSCAPES

In Germany, Munch was under pressure, with constant travelling, large commissions, a considerable number of exhibitions – and an unstable psyche. He was also leading a debauched lifestyle, drinking excessively at the Café Bauer in Berlin, among other places. Munch's letters from this period reveal his escalating nervous disorder and social paranoia. His friends expressed concern about his sometimes violent excesses – Munch might disappear for several days, only to be discovered in a miserable state.[4] His years-long stay in Germany finally came to an end with a nervous breakdown in the autumn of 1908, and his admission to a private clinic in Copenhagen run by Dr Daniel Jacobson.

Even before this catastrophic decline in his mental health, Munch would occasionally withdraw, to places in the countryside or off the beaten track. He went to spas or sanatoriums where he could receive treatment and care, living calmly as a convalescent. During these retreats from city life he would create landscape paintings, featuring motifs from the locations' immediate surroundings. The periods Munch spent at the Kornhaug sanatorium near Lillehammer and Hammers Pensionat on the outskirts of Oslo around the year 1900 gave rise to what could almost be termed a new genre: forest landscapes covered with snow. In Germany, Munch visited spas in Thüringen, Bad Kösen and Elgersburg, just outside Weimar. In Elgersburg he produced another series of closely related

snow-covered landscapes. The area was known for its mighty forests, castles and high mountains, but Munch seized on something else: the location's prosaic, agricultural landscapes, with their views across ploughed earth and fields covered in wet snow. These works signal a turning point in Munch's art, in several ways. He dialled up the intensity of his colours, light and brushwork, just as the younger 'wild painters' in Paris did. But the paintings also show something more: a dawning interest in agriculture, and all that sprouts and grows – traces of which can be seen in the earlier *Fertility*, where the gathering of ripe fruit was central. When Munch returned home to Norway some years later, this interest would blossom into full bloom.

In one of Munch's paintings from Thüringen (overleaf) we are led along, close to the ground, in a wintery torpor. The snow is on the wane, melting, and we detect the onset of spring – yet another theme linked to transformation, and Munch's interest in charged atmospheres. The organic linear interplay and oval shapes take on the contours of fluids, drops and bodily orifices. In the foreground, some meandering brushstrokes gather in a cleft that suggests something corporeal and sensual – the view is eroticized.

When Munch settled in Kragerø some years later, he turned to the subject of landscapes in wintery hibernation in earnest – this time with a focus on the forest and lumber. There is a related latent or implied sexual charging of the view in paintings such as *The Yellow Log* (overleaf).

EXPERIMENTS

Munch's painting technique became richer, wilder and more obviously experimental over this period. His application of colour spans from thick and dense to thin and light, his brushwork varies from sections with rough tracks and marks to finely painted areas. He used paints straight from the tube or the opposite – completely dissolved in solvent – and would often use vastly different techniques side by side in the same work.

Snow Landscape, Thüringen, 1906, oil on canvas, 84 × 109 cm.

The Yellow Log, 1912, oil on canvas, 129 × 160.5 cm.

In some of Munch's smaller paintings of the shoreline and wave studies from Warnemünde, the landscape is reduced to a kind of straight, horizontal strip without volume or depth, as in an abstract painting. The *Reinhardt Frieze* (overleaf) constitutes another extreme, a series of paintings created in 1907 especially for Max Reinhardt's new theatre, Kammerspiele, in Berlin (later dismounted). Here, the absorption of the paints into the canvas creates a subtle interplay of subdued, pale tones and a dry, brick-like surface. The motifs were taken from *The Frieze of Life* – human beings and the landscape at the edge of the forest by the fjord – but presented in a different way.

Around this time, Munch also began taking photographs.[5] Several of his colleagues, such as August Strindberg and J. F. Willumsen, had already worked seriously with photography, and towards the end of the 1800s photography became far more accessible. In 1902, Munch acquired a so-called 'Brownie' – a camera developed for the general public, manufactured by Kodak. Around the year 1900, the company transformed the photography industry, with the slogan 'You Press the Button, We Do the Rest'.

Munch's photographs display many typical amateur weaknesses: poor exposure, blurry subjects and weak contrasts. But they exhibit a visual curiosity and an interest in the medium itself – the approach seems free, playful and investigative. Most of the works are self-portraits, taken up close in the studio, together with a housekeeper, or in a posed situation. Others are of special places, such as the environs of Munch's childhood home in Pilestredet, Oslo.

Munch experimented with long shutter speeds and taking several exposures on top of one another. Figures appear like transparent apparitions passing through interiors, or are repeated in rhythmic movements. In several photographs from Warnemünde, Munch has taken full-length portraits of himself surrounded by his paintings. In one of them, a new version of *The Sick Child* shines through him – it seems almost as though the figure and painting are inseparable. Munch also explored

another side of the artistic profession through photographs taken on the beach, in which he positions himself as a heroic *plein air* painter.

Munch's photographs have a slightly unclear status. They were neither exhibited nor published during his lifetime, and Munch himself did not view them as being equal to his other works. But on the other hand, he did regard them as having value: 'When I get old, and have nothing better to do than potter about with an autobiography – then my photographic self-portraits will come to see the light of day'.[6] Munch never completed such an autobiography, but the photographs have since generated considerable interest. More than anything else, they show that the boundary drawn between art and other material can be fluid, and subject to change.

THE BREAKTHROUGH

It was during the years between 1902 and 1908 that Munch experienced his great breakthrough abroad. The scandalous exhibition in Berlin in 1892 had already earned him considerable fame in Germany, but now he was drawing a far larger and more important audience. Crucial to this breakthrough was the fact that Munch lived among the trendsetters of the contemporary art scene, of which he was a most active participant.

His presentation of a large number of paintings – which he would later collectively refer to as *The Frieze of Life* – at the Berlin Secession in 1902 was the start of a period of hectic activity, significant attention, and a huge number of exhibitions. The interest in Munch was firmly established – and growing. In 1904, Munch was discussed in detail in the first book about the development of the new art in Europe after impressionism,[7] and at around the same time he began exhibiting his works at Kunstsalon Cassirer, an important gallery in Berlin that was in close contact with Paris. The gallery promoted artists such as Cézanne, Van Gogh and Gauguin – this was a scene that crossed national borders in the advancement of the new, modern

Tree Trunks, c. 1920–30, oil on canvas, 68 × 134 cm.

Waves, 1908, oil on canvas, 108 × 95 cm.

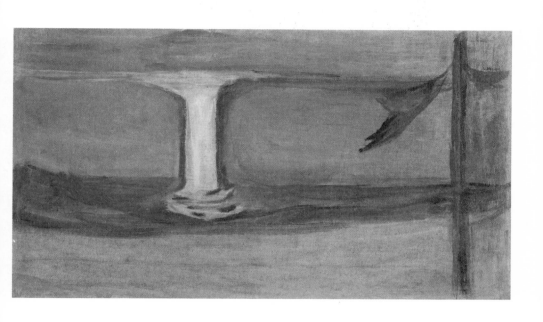

Moonlight on the Sea (The Reinhardt Frieze), 1906–7, tempera on canvas, 90 × 157.5 cm.

Self-Portrait in Am Strom 53 in Warnemünde, 1907, photograph.
Self-Portrait with Rosa Meissner in Warnemünde, 1907, photograph.

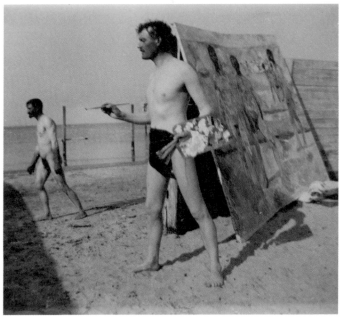

Self-Portrait with Suitcase, c. 1906, photograph.
Self-Portrait on the Beach in Warnemünde, 1907, photograph.

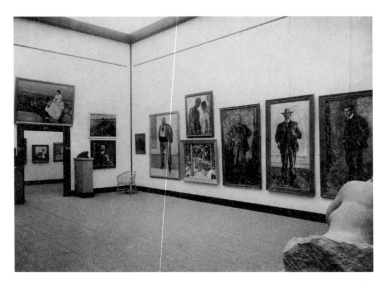

The *Sonderbund-Ausstellung* in Cologne, 1912.

painting. Munch found himself at the heart of the action – and his position paid off. At the vast *Sonderbund-Ausstellung* (Sonderbund Exhibition) in Cologne in 1912, he towered above many of the other artists as one of the most important figures in modern art. The aim of the exhibition was to provide a collated overview of modern art's development, and Munch and Picasso were the only featured canonized artists still living. But there was something else at stake in this exhibition – Munch was now also celebrated as a father figure for a new generation of German artists.

But Munch's continuous involvement in the emerging modern art scene in Germany had come at a price. Years of living in unstable conditions had taken their toll. Munch depicted some of the dark side of success in a highly direct way in the painting *Self-Portrait with a Bottle of Wine*. The artist we encounter here is a despondent one, sitting in three-quarter-length profile, left to himself in a restaurant. Light streams into the shining premises, the walls bare, the tables unset.

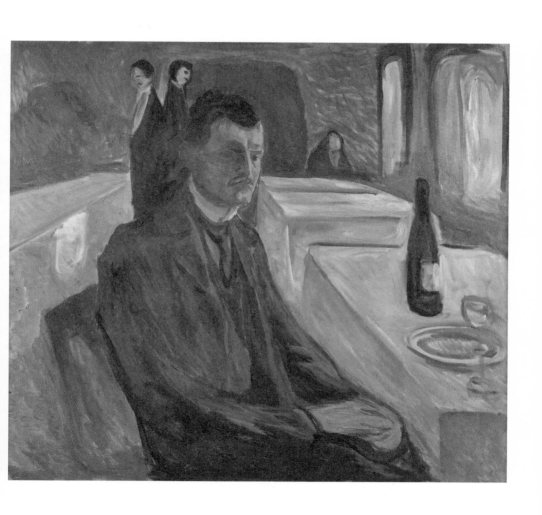

Self-Portrait with a Bottle of Wine, 1906, oil on canvas, 110.5 × 120.5 cm.

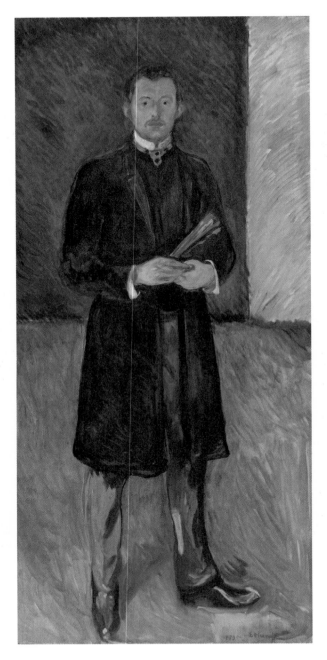

Self-Portrait with Brushes, 1904, oil on canvas, 197 × 91 cm.

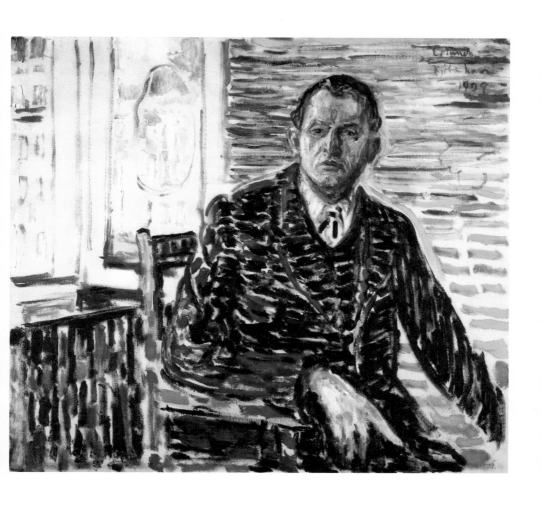

Self-Portrait in the Clinic, 1909, oil on canvas, 100 × 110 cm.

The night is young, the food has been eaten, and the wine bottle stands out as the only source of company at the party. Several rectangular fields echo the painting's surface, like a series of empty images within the image. Emptiness, and the relationship between the outer and something within, haunts the work. A red field at the centre frames the artist's face and draws attention to the eyes – one turned on us, the other turned inwards. The painting remains Munch's most prominent thematization of loneliness. Of course, it is possible to be alone without feeling lonely, just as it is possible to feel lonely while in the company of others – but something else is going on here, too. The artist looks exhausted. Modern and celebrated, but also worn out. A similar fatigue characterizes Munch's figure in a photographic self-portrait from the same period, in which he sits listlessly beside a suitcase. The contrast to the earlier *Self-Portrait with Brushes* (page 144) emphasizes this, but so does viewing the work in relation to the later *Self-Portrait in the Clinic* (page 145). In the former, Munch is an imposing, erect figure, vital and in full vigour, in line with the figures in his other full-length portraits – self-important in the fashion of the time, feet apart and brushes pointing diagonally up from his abdomen. The potent posture suggests a connection between sexual energy and creative ability, but perhaps in a slightly obstinate way? The later portrait was produced during Munch's stay at Doctor Jacobson's clinic. Strong colours and light, confident technique, straight lines – the effect is more systematic and daring, with a powerful impact. Broad, parallel brushstrokes form a pattern that binds all the shapes to the surface, as in *The Death of Marat*. The painting depicts the artist as convalescent, but he appears to have gained a new sense of balance and inner strength. The way in which he turns to us is more easy-going, neither withdrawn nor overwrought.

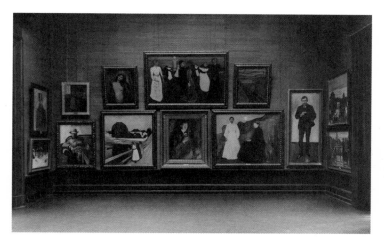

'The Munch wall' at the National Gallery in Oslo, 1912.

TOWARDS *THE SUN*

When his stay at Jacobson's private clinic came to an end in the spring of 1909, Munch resolved to change his lifestyle and return to Norway. He had had no permanent place of residence other than the little house in Åsgårdstrand for many years.
He needed to live differently, but there were also other circumstances that pulled him in the direction of his native country – in Norway, he was now enjoying significant success. During his convalescence he had been awarded the Order of St. Olav, and people were practically falling over one another to acquire his paintings. Jens Thiis had been appointed director of the National Gallery, and was highly familiar with Munch's work. Thiis would become an important source of support for Munch in several respects, including in the imminent competition that would determine who would be given the chance to decorate the Aula – the university's new ceremonial hall.[8]

Because back home in Norway, the centenary of the university in Kristiania was about to be celebrated. The institution had long desired an annexe – a place where people could gather for festivities and large events – and the construction of such an

History, 1911/14–16, oil on canvas, 455 × 1,160 cm.

auditorium was already under way. The hall was built behind the university's middle building, Domus Media, in the centre of the city. Inside, the architect had erected large wall panels, which now required decoration: the city's most distinguished art commission in living memory.

Munch had outgrown the house in Åsgårdstrand. He needed a place where he could work in larger formats and spend time outdoors – the time for painting large works had come. He soon moved to Skrubben in Kragerø, and in May 1909 he entered the competition.[9] He prepared some concepts and submitted various sketches, but the selection process was a protracted one, and when the university's anniversary celebrations took place two years later, the panels were decorated with nothing but silk wallpaper. The conflict regarding the decoration of the hall was prolonged, and took many twists and turns, but in the end it was Munch who was awarded the commission. Meanwhile, his works had come to be regarded as modern classics overseas, and this did not go unnoticed in his home country. Munch won the competition partly because he had many supporters and strong strategic skills – but first and foremost because his concept, with *The Sun* (overleaf) emblazoning the main feature wall, flanked by *History* and *Alma Mater* on either side, proved the superior submission.

Munch's concept started with *History*, the image of an old man and a little boy sheltered by a mighty oak tree in an open, coastal landscape. The man imparts his wisdom to the boy, echoing the fundamental purpose at the core of the university as an institution. Some critics were disappointed that the old man was an ordinary workman in patched and mended clothing, but this choice emphasized the value of the universal transfer of knowledge within society. The painting articulates this theme across class divides and generations, and through nature the theme was linked to the country, uniting the young nation of Norway. That Munch's own uncle, P. A. Munch,[10] had been one of the country's foremost historians reinforced the point, and with the introduction of the sun – a vitalist symbol

of regeneration and renewal – as the room's main motif on the feature wall, the theme was raised to another level.

Unlike *The Frieze of Life*, which portrayed the individual's joys and sorrows up close, in these decorative works Munch sought to depict the great, eternal forces of nature that affect all humanity.[11] *The Sun* encapsulates this effort to capture something as simple yet awe-inspiring and universal as the rising sun. The sun's rays shoot out from its centre, and the centre of the piece, with tremendous energy, radiating towards and beyond the painting's outer edges, out into the auditorium and the adjacent panels. No figures are present in the work to witness the spectacle. The sunrise had, of course, been painted without the inclusion of human beings before, but never like this. *Alma Mater* was created last, together with the smaller panels that depict various enriching aspects of life based on light, fertility and knowledge.

The works explore grand, universal themes, but also have some down-to-earth elements: the patches on the old man's trousers, the coastal rock formations, the flowers in the grass, the little cluster of birch trees, the old man's red cap. The motif of *The Sun* grew out of the view from Munch's residence at Skrubben, the figures through studies of models from the fishing town of Kragerø. Even in his most conceptual works, Munch kept a firm grip on a motif's origins in something seen and observed.

WHY?

What were the driving forces behind Munch's artistic reorientation in the early 1900s, and how did they take shape? This is a topic much discussed among Munch scholars. Some place primary emphasis on his mental breakdown – Munch's period at Dr Jacobson's clinic was undoubtedly the start of a new phase in his life, but was it decisive in terms of the changes in his work? Well, yes and no – Munch's change in direction appears to have been initiated several years before his breakdown.

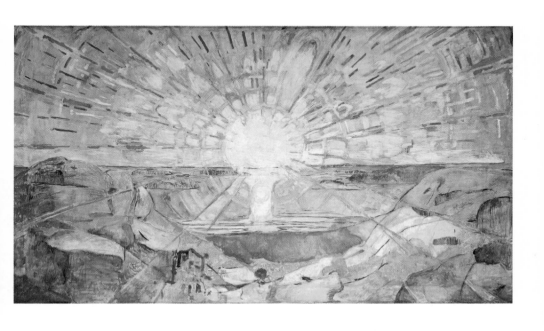

The Sun, 1911, oil on canvas, 455 × 780 cm.

The Aula (ceremonial hall), University of Oslo, completed in 1916.

Others have pointed out the importance of Munch's visits to Warnemünde: a curative environment, summer sun and new impulses; his contact with the Nietzschean scene in Weimar has also been attributed great significance. A trip to Italy in 1901, where Munch encountered the monumental art of the Renaissance and baroque periods, may also have played a certain role. One explanation doesn't preclude another, but Munch's proximity to what was going on within the cutting-edge art of the age must be considered significant – he wanted to be a part of this. Munch had proven himself a pioneering artist with his works from the 1890s, but it was through his radical artistic renewal over the following years that he became an artist who would continue to be held in high esteem well into the twentieth century.

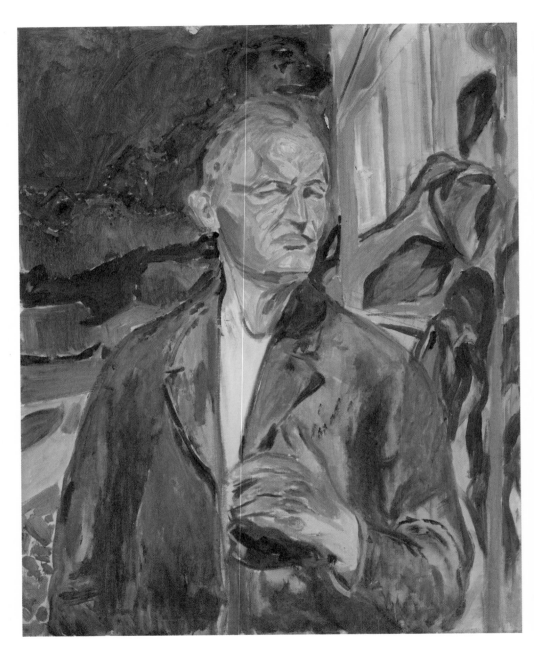

Self-Portrait in Front of the House Wall, 1926, oil on canvas, 91.5 × 73 cm.

EKELY (1916–1944)

IN 1916, MUNCH MADE A PURCHASE that would come to influence much of his artistic activity for the rest of his life. He acquired a property named Ekely, just west of Kristiania, and moved back home to the city that, more than any other, had shaped him as an artist.[1]

The property was situated at the border between the city and the countryside, north of Skøyen. Secluded, but not too far from the fjord, railway, and an area undergoing industrial development. A spacious, yellow Swiss-style villa towered above the eleven-acre agricultural property that included gardens, a nursery, a small forest and a red-painted outbuilding – the servants' quarters. The extensive site cost 75,000 Norwegian kroner; for comparison, the annual salary of the director of the National Gallery at this time was around 5,000 kroner.[2] Munch, who just ten to fifteen years earlier had continually been forced to ask others for money, was now comfortably well-off.

With the outbreak of the First World War in the summer of 1914, Munch lost contact with many collectors, gallery owners and supporters in Germany – but the market in Norway was on the rise. Norway's neutrality resulted in an economic boom, and Munch's works were simultaneously becoming increas-

ingly sought after. Headed by Jens Thiis, the National Gallery had acquired an astonishingly large number of his paintings in 1909 – even controversial works such as *Puberty* and *The Day After* were now part of the gallery's collection. This provoked strong reactions – Munch's art was obviously still capable of inciting indignation:

> How long will the drunken girl in *The Day After* be allowed to sleep off her hangover in the state's art museum? And how long will the museum director who has effected such an acquisition with the ministry's support be permitted to remain in his position?[3]

But Thiis refused to be ruffled. Supplemented with several major works gifted by collector Olaf Schou, Munch's paintings now adorned an entire wall of the country's foremost art institution.

Munch had long been on the lookout for a permanent home. The Skrubben property in Kragerø was not for sale, and the fisherman's cottage in Åsgårdstrand was now too small. Neither the summer house he purchased in Hvitsten in 1910, nor Grimsrød manor, which he rented in Moss, was sufficient. But Ekely was something else. The plot provided plenty of space, and was closer to his network of supporters, collectors and potential clients. The gardener from whom Munch purchased the property had planted fruit trees, cabbage and various other vegetables – these would come in handy if the war dragged on and produce became scarce.

Munch was well aware of the fortunate situation in which both he and his homeland found themselves. In a lithograph created in connection with a presentation of Norwegian art in Copenhagen in 1915, he commented on the situation with bitter irony. Under the title *Neutralia*, two paradisiacal, naked and 'Nordic' humans help themselves to a tree's abundant fruit, while in the background a boat toils upon the dark, raging sea.

Neutralia, 1915, lithograph, 77 × 50 cm.

Man in the Cabbage Field, 1916, oil on canvas, 136 × 180 cm.

The Ekely phase of Munch's art is framed by two world wars, and spans the darkest period in Europe's history. Munch withdrew from the world slightly during this time, particularly after he contracted an eye disease in 1930. But his works testify to the fact that he remained in touch with current events during this period. They manifest his attitudes, opinions and values, which are evident in, for example, his growing interest in ordinary working life and all that sprouts and grows; edifying themes associated with fertility, a lust for life, and human efforts here on earth.

GROWTH OF THE SOIL

Ekely's open agricultural landscape set the tone for *Man in the Cabbage Field*. Munch had never worked out in the fields in this way, but he had retained the ability to put himself in other people's shoes. His depiction of a farmer harvesting the fruits of the soil contains much of the Aula paintings' simple, elevated monumentality. Toil and exhaustion are painted into the figure's body language, eccentuated by the sharp sunlight, the faceless figure, the gaping mouth. The energy that lies in the bold colours and sweeping brushstrokes supports the vitality and deep meaningfulness of the work being undertaken. The farmer is presented as a hero, but without his hard labour being rendered idyllic, or romanticized. The sun beats down; sweat drips from him as he bears the weight of the cabbages. But the painting is not so much about social criticism. It has more to do with the modern, urban individual's rose-tinted notions of a life lived in close contact with the land.

The farmer's efforts are celebrated in a cascade of colours, dominated by green and blue. Artistically speaking, the man and the landscape merge into one another, as if in a higher synthesis. A deep appreciation lies in the depiction, with the figure in royal blue and inscribed sacredly in an upright triangle. Again, we are presented with an individual engrossed in the task at hand, as we imagine Munch must have been when he

painted the image – and as we are when we look at the painting. A connection arises between the farmer's toiling in the field, the artist's work on the painting, and the viewer's analysis of the work.

Earlier in his career, Munch had little interest in motifs taken from the life of the farmer. Quite the contrary, in fact – the genre was part of that which he had opposed as a young artist, and from which he had wished to distance himself. But at Ekely, the situation had changed. Munch was now an artist who was becoming ever more famous, and who had left behind the fast pace and excesses of life in the city. Cultivating fruit, berries and vegetables was now part of his everyday life, and his environs were transferred directly onto his canvases. In other words, the conditions were right for Munch to enter into a dialogue with his predecessors' depictions of farmers, and of life on the land.

In Norway, Adolph Tidemand and Erik Werenskiold had exalted the figure of the farmer as a collective national hero. Munch did something similar, but with greater emphasis on an agricultural yearning, and in a more painterly, unrestrained, bright and modern way. In terms of its brushstrokes and colours, the painting is every bit as lush as the cabbages in the farmer's arms.

The celebration of agriculture, the fertile, and a life spent in harmony with nature was in the air at the time – a reaction to the modernization that had cast Europe into a great, meaningless war. The year after Munch completed the painting, Knut Hamsun published *Growth of the Soil*, featuring the pioneering farmer Isak Sellanraa as a national hero. The book became a bestseller, and won Hamsun the Nobel Prize in Literature some years later.

WORKERS

Munch maintained a deep sympathy for ordinary people, even after he himself had become rich and decidedly extraordinary. Throughout the 1910s, Munch explored another group of subjects, focused on everyday workers – a relatively new class of people within Norwegian society. This was a group of images that Munch thought might contain the seed of a large new frieze: a *Frieze of Workers*.[4]

At Ekely, Munch returned to two motifs he had explored during his time in Kragerø and later at Grimsrød manor in Moss: workers in the snow, and workers returning home (overleaf). In both cases, a group of people fills a large area of the painting, either standing and turned to face us, or walking towards us. Those in the foreground are clearly individuals, but towards the background they merge into a shapeless mass. In *Workers in Snow*, the figures have apparently stopped their work and lined up, shovels demonstratively set forth, almost as if posing for a photograph. The composition has much in common with *Bathing Men* (page 125); the figures exude a similar masculine strength. Munch varied the motif in many paintings and used different techniques, but with the same relationship between individual and group.

What is striking about these paintings is not the subjects' activities, circumstances or social status – rather, the workers are emphasized as belonging to a social group, or being part of a new growing social class. Munch took an early interest in the growth of the working class, a process that surged ahead in the decades leading up to 1920 as industrialization increased, bringing with it heightened class consciousness and conflict. The revolution in Russia in 1917 highlighted this, with the dramatic societal changes and executions of aristocrats that accompanied the introduction of the 'dictatorship of the proletariat'.

Workers had already been introduced as a theme in art, but usually from a standpoint of social criticism. In Munch's works, however, attention is directed more towards the ambition, strength and potential of this new social class, with the workers

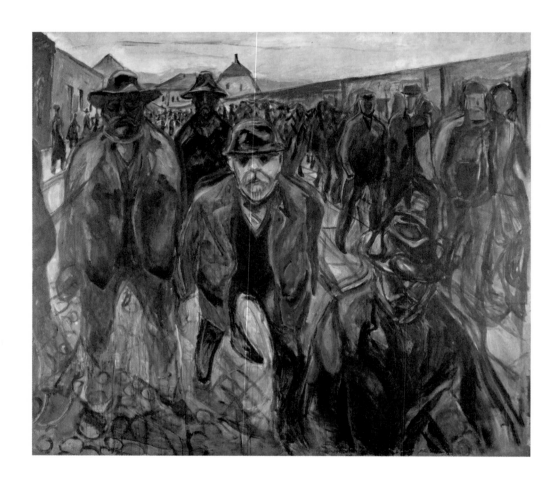

Workers on Their Way Home, 1913–14, oil on canvas, 201 × 227 cm.

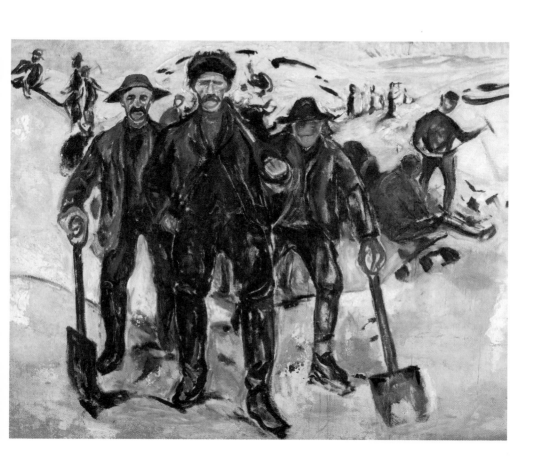

Workers in Snow, 1913–15, oil on canvas, 163 × 200 cm.

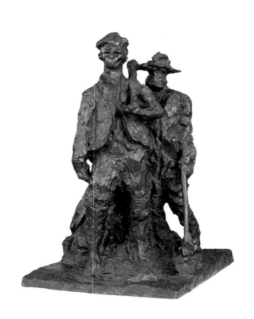

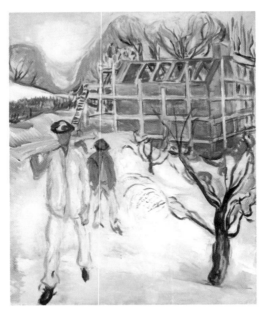

Workers in Snow, 1910, bronze, 70 × 56.5 × 45 cm.
Building Workers in Snow, 1920, oil on canvas, 127 × 103 cm.

presented as the new cornerstone of society. The workers that appear in Munch's paintings can be interpreted in different ways, and the fact that the figures' physical appearance can be viewed as both vitally powerful and threatening was commented on by Munch's contemporaries. Munch's friend, the art critic Jappe Nilssen, wrote about the impression of something violent and frightening in encountering them: 'the overwhelming, unstoppable force that comes rolling over you'.[5]

Munch's worker paintings bear witness to a certain intimacy that he felt with people from the working class; otherwise, the depictions might easily have become stereotypes. In his youth, Munch lived in the working-class district of Grünerløkka, and as his father was a doctor, he met many of the people who lived in the local community. Later, he often got along well with people from the proletariat in the coastal places he lived, such as Åsgårdstrand, Warnemünde and Kragerø. Several of these individuals posed as models for him, and became Munch's friends for life. In and around Ekely there were many farmers and domestic workers, while slightly south, towards Skøyen, was a large, booming industrial area with mechanical workshops, factories and workers' dwellings. This proximity to working-class communities and people of humble means probably helped to lend Munch's worker paintings a degree of authenticity. We get close to the workers – or they come close to us.

The theme of the worker became Munch's great project at Ekely, but he never completed his intended *Frieze of Workers*, conceived for one of the dining halls at the Freia chocolate factory in Kristiania; the commission was realized in 1922, but instead using paintings loosely based on old motifs. Many were keen to see the new Oslo City Hall become the location of Munch's last large-scale project, but the process was delayed and the frieze remained incomplete. Munch's interest in people at work did, however, result in a number of monumental, loosely connected paintings.

SPANISH FLU?

Around Christmas 1918 Munch fell ill, perhaps having contracted the Spanish influenza – a deadly epidemic that raged across the world and claimed the lives of over fifty million people. Yet again, Munch returned to the themes of illness and death, but now with himself as the protagonist. In several studies, sketches and paintings he tracked the course of his illness, and how the threat of death loomed ever closer. All this was summarized in a large painting depicting his enfeebled state, in which he sits before an unmade bed.

The vast painting makes an overwhelming impression with its toxic, yellow-orange tones and thick layers of brushstrokes. The open mouth and wicker chair give a nod to *The Scream* and Munch's death motifs from the 1880s and 1890s, but the artistic register here is in tune with his creative renewal. The force in the brushstrokes and the painterly execution stand in contrast to the element of physical deterioration in the theme of illness. It is, truth be told, a little difficult to imagine that the artist could have managed to complete such a monumental and demanding painting in such a seriously impaired state of health as suggested by the work's title. Based on available source material, we are unable to say with any certainty that Munch was actually suffering from the Spanish flu when he painted the work, and this point underlines an important dimension of Munch's many self-portraits – that they at times feature an aspect of dramatic self-staging. Munch appears not only as a soul-searching, authentic individual who reveals himself to us, but also as a dramatist who creates images of himself as he wishes to be perceived. The willingness to explore and expose the self goes hand in hand with seductive and mythologizing elements. In fact, during his time at Ekely, Munch became especially concerned with his posthumous reputation and how he would appear to future generations.

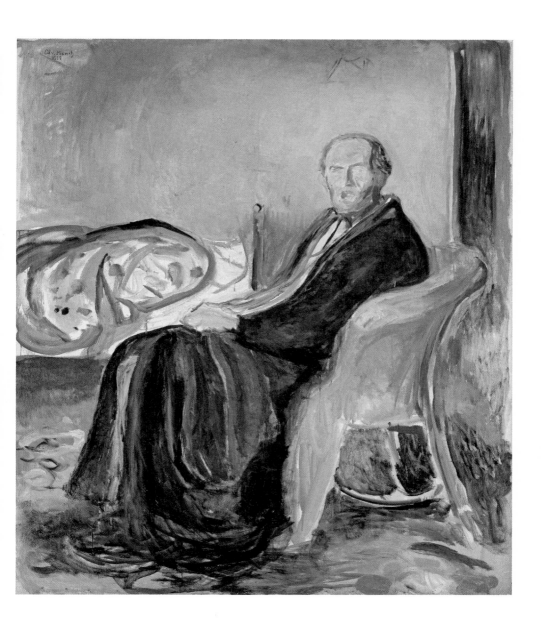

Self-Portrait with the Spanish Flu, 1919, oil on canvas, 150 × 131 cm.

THE INTERWAR PERIOD

In the decades that followed the First World War Munch became prosperous, and experienced many of his greatest successes. He re-established contact with the continent, and many of Europe's great artistic centres now showed interest in his work. In 1922, the Kunsthaus Zürich arranged an extensive exhibition of Munch's works, which then travelled to Bern and Basel; the Kunsthalle Mannheim followed with an exhibition in 1926. The climax came in the spring of 1927, with the largest-ever presentation of Munch's works, at the National Gallery in Berlin. Over 220 paintings were displayed at the museum, which had the most advanced contemporary art department in Europe: 'Galerie der Lebenden' in the Kronprinzenpalais. One of the reasons that the museum's director, Ludwig Justi, supported and elevated Munch was his importance for a new generation of German artists. Munch had already been launched as a kind of father figure for German expressionism at the *Sonderbund-Ausstellung* in Cologne in 1912. But now national character was

Edvard Munch at the National Gallery in Berlin in 1927.

on the agenda, and Justi highlighted expressionism as something typically German. It represented the radical, modern and innovative aspects of the country.

Munch also garnered wide-ranging institutional acclaim in the Nordic region during the interwar period. Rasmus Meyer's collection, in which Munch was richly represented, was displayed to the public in Bergen in 1924. Two years later when the Thiel Gallery opened in Stockholm, based on Ernest Thiel's large art collection, an entire hall was devoted to Munch's works. In Oslo, the National Gallery took over the large exhibition from Berlin – the final confirmation that Munch was now a canonized modern master.

NEW VERSIONS

At Ekely, Munch created many new versions of older, long-established motifs such as *The Kiss, Vampire, The Girls on the Bridge* and *Dance of Life*, but the new versions were often formulated quite differently; old material, in new wrapping.

In the 1800s it was usual for artists to create and sell several versions of their most famous works, so-called 'replicas'. Artists such as Claude Monet, on the other hand, had developed a new way of thinking about repetitions. The interplay between repetition and variation permitted greater attention to be devoted to light, colour, nuance and texture – and even to the painterly execution itself, shifting the focus from subject to execution.

Unlike Monet, who painted homogeneous depictions of haystacks and façades one after another as if in an ongoing series, Munch created his new versions many years apart. They were also characterized by where he was in his artistic development at any given time. At Ekely, he returned to old motifs with new approaches, colours and aims. A motivating factor in many of these new formulations was the dream of finally being able to realize *The Frieze of Life*. The old paintings were spread across various locations, in museums and private collections,

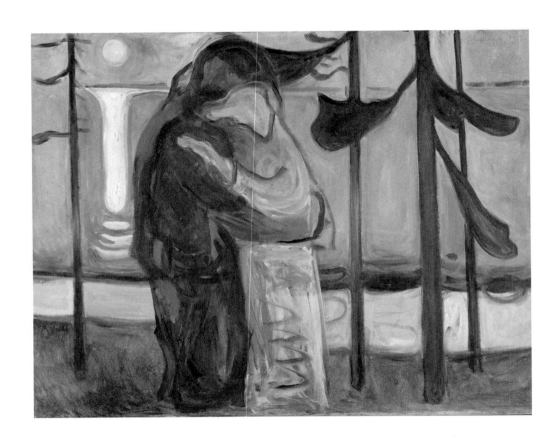

Kiss on the Shore by Moonlight, 1914, oil on canvas, 77 × 100 cm.

Dance on the Beach, 1921–22, oil on canvas, 200 × 310 cm.

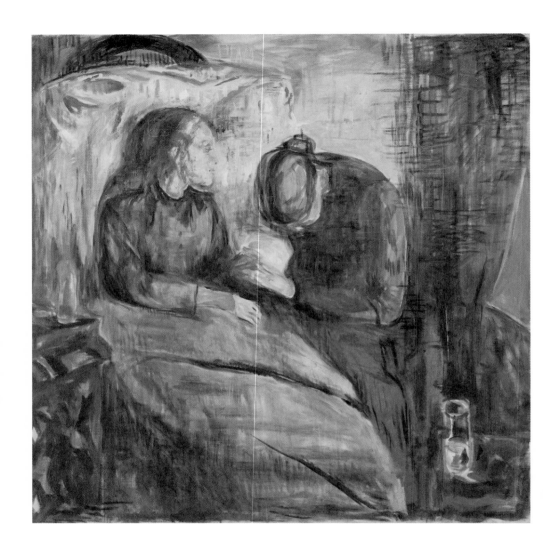

The Sick Child, 1925, oil on canvas, 117 × 118 cm.

but of course they could also be recreated. One of Munch's great ideas had always been, and remained, that his works 'belonged together'.

The Sick Child was the motif Munch returned to most often, and over the longest period of time. He created six paintings based on the motif over a period of forty years – the format, composition and perspective were always the same, but the execution varied. The paintings are the same, and yet different. Viewed together, they reveal Munch's development as an artist: from painterly realism to intense expressionism, and from explosive colours to decorative surface painting. When the motif is repeated in this way, a shift in attention occurs: from the depiction of experienced reality and emotional content, to a greater emphasis on the formal execution. Recurrence and repetition in themselves have a depleting effect. When a motif is repeated many times it becomes abstracted, uncoupled from its original starting point and content. The continual return to The Sick Child confirms this motif's status as especially important, but it simultaneously becomes an empty visual symbol that can be filled with new dimensions, or given a different kind of attention – precisely *how*, rather than *what*.

THE 'KILL-OR-CURE REMEDY'

Dance on the Beach (page 171) is a fairly free, new execution of Dance of Life from 1900. But the surface of this painting is strange, featuring damage, scratches and marks that are obviously not part of its creation: traces of bird droppings, water stains and peeling and weathered paint. The work has obviously been left outside, uncovered, at the mercy of the elements. It has probably been subjected to Munch's legendary 'kill-or-cure remedy'[6] – a term he used about paintings that he left outside as a kind of punishment, either in frustration or in the hopes of improving them.

To what extent this practice was a strategic, artistic working method, or simply a result of carelessness, irritation or a lack of viable storage options is unclear, but we know that Munch nurtured a rather nonchalant attitude to his works. Spills and minor damage were allowed to remain, or he might even ensure that his paintings were treated roughly. A number of his works bear clear signs of damage and marks that did not arise through the painting process. This openness to chance occurrences and the impact of his surroundings became an important part of Munch's artistic activities early on; it is evident in some of his works from the 1890s, such as *Separation* and even the first version of *The Scream*, on which the remains of melted candle-wax can be seen. At Ekely, however, Munch went even further. He might leave his paintings lying around or outdoors, exposed to the forces and fluids of nature – and often for prolonged periods of time. After Munch's death, when the recording of his estate began in February 1944, paintings were found all over Ekely. Sigurd Willoch, who would later become director of the National Gallery, participated in the work and gave a vivid description:

> It was well-known that Munch carelessly left his paintings in open outhouses, his so-called open air studios, but there were paintings oozing out from everywhere....An entire collection stood in a tiny box room up a narrow staircase in the outhouse, which also housed a cowshed, hayloft, workshop and other hazardous activities....Huge versions of the Aula paintings endured a wretched existence outdoors, covered with dead birch leaves and seeds.[7]

Kill-or-cure remedy or no, many of Munch's works were subjected to such treatment during the Ekely period – some are so battered that they appear to be in ruins. And yet they invoke fascination and interest – not only because of their unconventional aesthetic qualities, but also because these kinds of works have a challenging status as art. They test us – the line

Separation, 1894, oil on canvas, 115 × 150 cm.

between art and rubbish can be difficult to draw. How were they perceived in Munch's time? And how are they regarded today?

At the time of their creation, Munch's 'kill-or-cure paintings' occupied a marginal position. They were unsigned, seldom included in exhibitions and never discussed in contemporary analyses – it is only more recently that these works have been brought into the spotlight. They exhibit qualities and features that might previously have gone unnoticed, perhaps even by Munch himself. This is how historical processes work – contemporary judgments are re-examined by subsequent generations.

The very definition of art has changed since Munch's time – it has become more elastic, and receptive to marginal phenomena such as these. We have become more used to peculiar painterly expressions and process-oriented ways of working. In addition, many of today's contemporary artists are interested in interaction and random occurrences – in opening the work up to influences beyond the artist's control.[8]

THE MODELS

There was no significant decline in Munch's interest in love and desire during this period, but he expressed these themes in new ways. In the painting *Model by the Wicker Chair* (overleaf), a young, naked woman is depicted in sensual, curving brushstrokes. Her pale skin shines carnally against her surroundings, which are dominated by warm colours. Her head is bowed. She seems exposed, shy, perhaps even ill at ease. The intimacy of the situation is amplified by the room in which she stands, which is untidy and somewhat vague, while still readable as a private space. Is she standing in a bedroom?

At Ekely, Munch worked closely with individual models, such as Annie Fjeldbu, Hildur Christensen, Birgit Prestøe (later Birgit Olsen) and Hanna Selquist.[9] He preferred younger, beautiful women with long, slim bodies, like that of the woman standing by the wicker chair. The same person recurs in many paintings, over a period of many years. The study of the naked

female body was central, but the sources we have say nothing of any form of undesired sexual attention from any of the parties involved. Traditionally, artists' nude models came from poor backgrounds – they might be sex workers, and were sometimes taken advantage of as lovers. But this was apparently not the case with Munch's models. Nothing indicates that there was anything more to the relationship between artist and model at Ekely – at least in terms of overtly sexual relations.[10]

That being said, many of the portrayals of the naked female body created by Munch in his later years were erotically charged. The paintings are a continuation of a long line of depictions of women, but it is as if Munch's former ambivalence – the battle between attraction and aversion, potency and powerlessness – has faded away. The paintings convey a greater sense of restrained sexual impulses, and there is also something revealing of the artist about them. In some works, an ageing male figure is included, his desire for the young, female body exposed almost as a caricature.

In his drawings and watercolours in particular, Munch connects erotic motifs with the sensuality inherent in the creation of the image: scenes of seduction and loving couples reproduced in quick, energetic lines that indicate longing, or the nude female body laid out as sensual and seductive in a fluid haze of watercolours.

In *Model by the Wicker Chair* the shapeless red chair projects an eroticism, its jumbled, curving brushstrokes hinting at a desire at play beneath the surface. Colours, lines and shapes stimulate and insinuate, but without fully revealing anything. At Ekely, it is as if Munch's interest in sex and love takes a new turn – but this is not just about restrained erotic desire. Two full-length portraits of Birgit Prestøe bear witness to a fascination with the female personality.[11] In *Krotkaya* (page 181) she is naked, but also reserved, vulnerable and exposed. In *Woman in Grey* (page 180), she is on her way out, no longer just a model but an individual, with her own life and psyche. She stands at the border between being a model and being herself.

Standing Nude Female Blue, 1922–24, watercolour, 50.5 × 35 cm.
Kneeling Female Nude, 1921, watercolour, 35.5 × 50 cm.

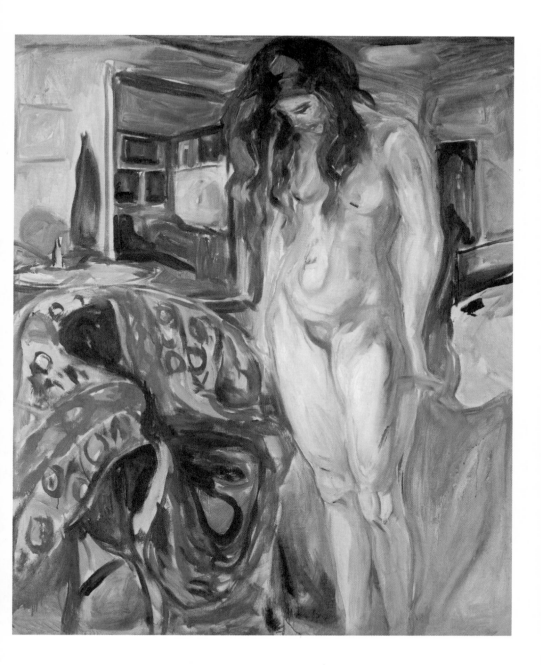

Model by the Wicker Chair, 1919–21, oil on canvas, 122.5 × 100 cm.

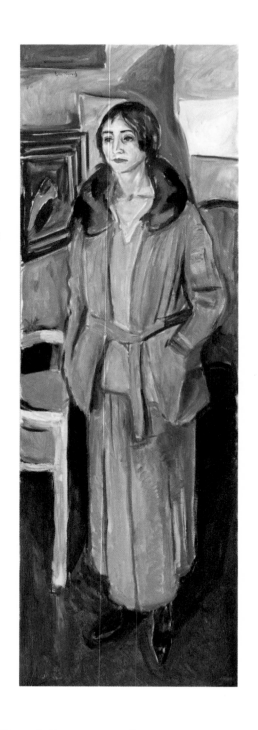

Woman in Grey, 1924–25, oil on canvas, 180 × 59 cm.

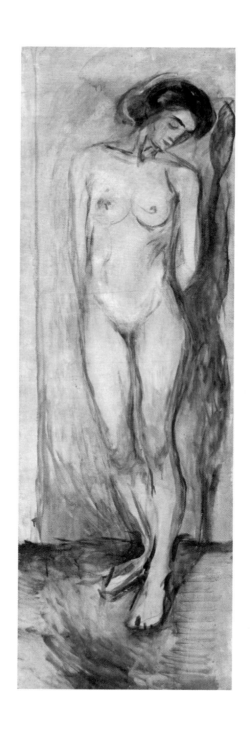

Krotkaya, 1927–29, oil on canvas, 177.5 × 58.5 cm.

ART AND LIFE

At Ekely Munch often painted outdoors, and many of the works he created were light, lucid and colourful. Munch's paintings of the lush garden in particular demonstrate his unrelenting drive to create, and his undiminished skill. Munch himself referred to his works as his 'children', and they now swarmed forth in huge numbers. Often, the immediate surroundings served as the initiator of painterly explorations and analyses of the passing of the seasons. The view from the property was diverse: some green hills towards the west, the fjord to the south, the lights of the city to the north-east, and a small forest of old, knotted elm trees close by. The red building that housed the servants' quarters was often used as a point of focus, painted from various angles, at different times of day, and in varying light. Munch shared this interest in gardens with several other modern artists, such as Claude Monet, who cultivated large gardens in Giverny. The garden was a place where the artist could become immersed in the instruments and possibilities of painting; explore light and the effects of colour, compositional approaches, and the expressive power of each brushstroke. But Munch often combined this with some kind of human presence: people at work, or simply outdoors, and most often women. Traces of people are present even in works where they are not visible. This reminds us of how Munch started out by describing himself as a painter of everyday life.

During the period he spent in Kragerø, Munch had started painting scenes of animal husbandry, with horses and dogs being popular models. Two horses, one light and one dark, constitute a striking pair of contrasts in lavish depictions of harmonious coupledom, during ploughing and in other situations. Or a single white horse, in lonesome majesty. The way in which the animals are portrayed is an extension of Munch's long-standing interest in everyday life, but it also bears witness to a finely tuned ability to observe; to discern not only the typical, but the nuances, too. In one small painting,

Rugged Tree Trunks in Summer, 1923, oil on canvas, 100 × 125 cm.

Apple Tree in the Garden, 1932–42, oil on canvas, 100.5 × 77.5 cm.
Still Life with Tomatoes, Leek and Casseroles, 1926–30, oil on canvas, 49.5 × 61 cm.

Five Puppies on the Carpet, 1919–21, oil on canvas, 50 × 80 cm.

The Wave, 1931, oil on canvas, 100 × 120 cm.

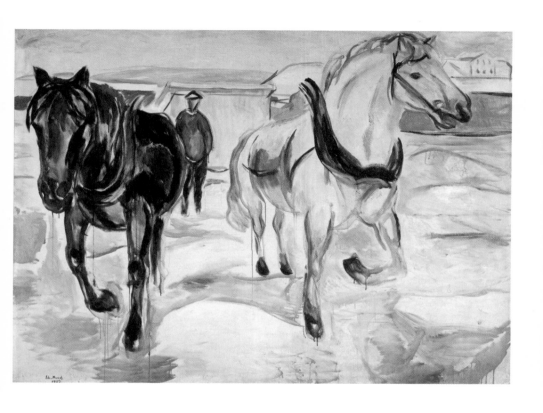

Horse Team in Snow, 1923, oil on canvas, 134 × 181 cm.

five puppies romp on a colourful rug. They look the same, but are perceived and presented as being different. Upon closer inspection, they seem to have distinct personalities as they walk, sit, stand or crawl. Again, we are witness to the relationship between individual and group – a familiar theme, but formulated on the basis of different conditions than before. As in so many of Munch's paintings, one of the elements intersects the foreground, in this case one of the puppies, while another seems to have stopped to meet the viewer's gaze. There is much that happens on the sidelines and around the gaze in Munch's works. Information, minor motifs and painterly traces appear in the image's marginal areas, alongside the main subject. The viewer's gaze is cast out to roam around the painting.

Munch erected several outdoor studios around the property, semi-covered and with high wooden fences. It was as if everything at Ekely was trained on this one single purpose: the creation of art. The animals posed as models, new studios were established – indeed, even the work to erect them and grow the food on the table might become fruitful subjects. The rooms of the yellow villa were transformed into workspaces and showrooms, and painting and photography undertaken anywhere and everywhere. Prints, drawings and lithographs were created, models came and went, collectors knocked at the door. Some filming even took place – Munch always kept up to date with the latest techniques. Everything was connected: life and art became one.

If there were too many distractions at Ekely, Munch could easily take a trip to the fisherman's cottage in Åsgårdstrand, or to his preferred location in Hvitsten; to the empty beaches of the open archipelago. In Hvitsten, in particular, Munch created many bold, colourful landscapes during this period, using simple, suggestive techniques. The visual echo effect in The Wave (page 186) illuminates the wind and the rhythm of the waves, capturing the sensation of standing in a landscape in motion.

NIGHT PAINTINGS

In *Starry Night* (overleaf), Munch returned to one of his favourite motifs of the late 1890s – the clear night sky filled with stars, above a dark landscape – but now, the lights of the city can be seen far off in the distance. The scene is viewed from a veranda with two railings that lead the gaze inwards, framing the motif. The landscape is built up using dense, flat shapes, in contrast to the translucent starry sky, which is executed using thin paint and rough brushwork. The warm light makes the city sparkle like a Soria Moria castle in the distance, and in the foreground, a glimpse of a strange shadow. Is this cast by the artist himself, or perhaps the person who stands looking at the picture? The depictions of night have a deeper, more melancholy tone than his earlier works, as if Munch's advancing age has placed them in connection with the great mystery of life. In *The Night Wanderer*, Munch has depicted himself as an old man, walking around the large villa as if on his way to the other side.

TWO PHASES

The Ekely period can be understood in two phases, divided by a passing eye disease Munch contracted in 1930. The first phase is characterized by Munch's ambition to create a *Frieze of Workers*, and his interest in edifying, fertile and colourful subjects, alongside continuous reflection on his own oeuvre. Munch returned to old motifs while simultaneously exploring the idea of establishing a museum dedicated to his works. Would his ambition to complete *The Frieze of Life* then finally be realized? In his struggle to justify the frieze, Munch published several texts about the significance it had had for his work and what it was really about: '...a number of decorative pictures, which together would represent an image of life....They will be people who are alive, who breathe and feel, suffer and love.'[12]

The second phase spans the last fifteen years of Munch's life. In Norway, Munch was now thoroughly established as the country's great modern master. He turned seventy in 1933, and

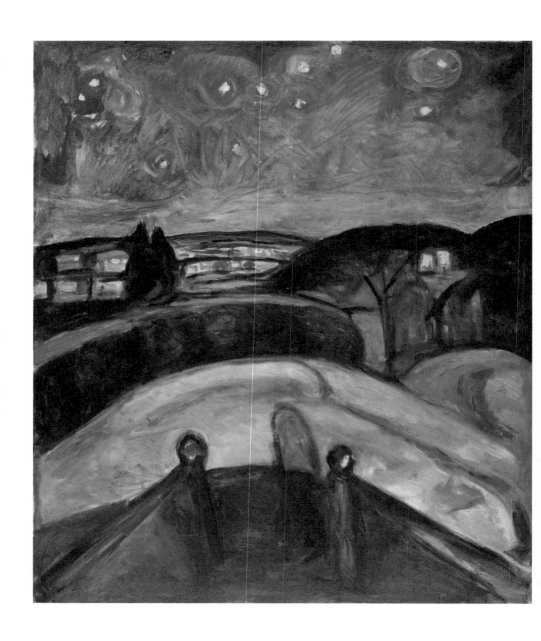

Starry Night, 1922–24, oil on canvas, 140 × 119 cm.

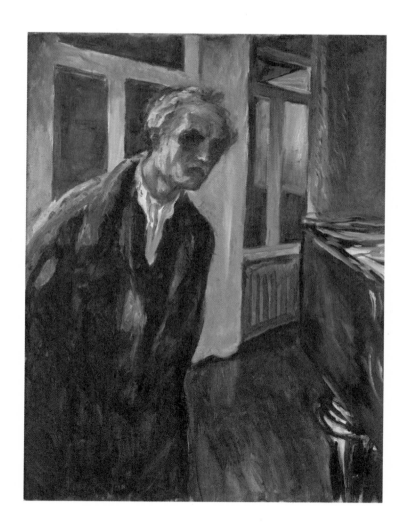

The Night Wanderer, 1923–24, oil on canvas, 90 × 68 cm.

in the same year two comprehensive books about him were published, written by Pola Gauguin and Jens Thiis, respectively.[13] A few years later, a new hall in the National Gallery was prepared to exhibit a broad range of Munch's works. With a generous gift from the Mustad family, the gallery's collection now included over fifty of Munch's paintings. This permanent space quickly became known as the 'Munch hall'. Henrik Ibsen was right – Munch's experience had been the same as his own: 'the more enemies you make, the more friends you acquire'.[14]

NEW PATHS

Munch now changed his artistic direction yet again. He started working with completely flat shapes and large, monotonous fields of colour, as in *Two Women on the Shore*. The application of colour and the material effect were also different. Another characteristic of his work during his final years was a continual stretching of the line between sketch, completed work and discarded material. This is a line that is fluid and difficult to draw in relation to modern art in general, but especially in Munch's case, since he seems to have kept almost everything he created. As we have seen, he habitually left his works idly lying around. Initially, loosely formulated paintings such as *Jealousy Motif* (overleaf) were probably only intended as rough sketches or unsuccessful attempts – but on the other hand, they were never discarded. The fact that Munch kept them suggests a kind of recognition of their value, even though such works might only serve as reminders, or working notes. Faced with works such as this, we are reminded of the significance of the unfinished in Munch's art. It was the incomplete element of his works that critics had always focused on, and which Munch himself refused to let go of because it retained the first, immediate impulse.

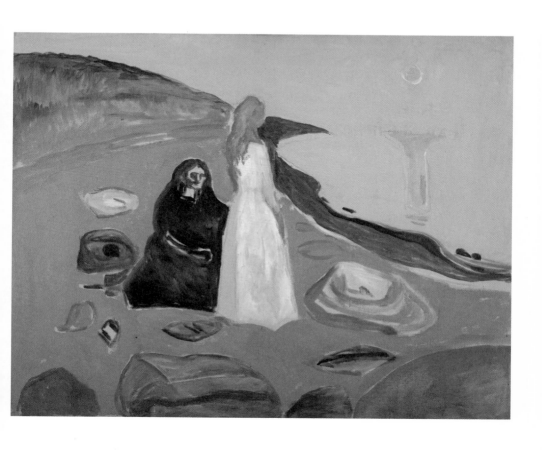

Two Women on the Shore, 1933–35, oil on canvas, 93 × 118 cm.

Jealousy Motif was probably a discarded sketch.[15] Today, the fact that it is exhibited as a satisfactory, independent work of art is due not only to the fact that our aesthetic preferences have changed, but because in it some of the central themes of Munch's work are taken a few steps further. Through the painting, an established motif is formulated in a notably 'advanced' and modern way, not unlike the way in which several artists turned their attention to the art form around the year 1980, experimenting with similar quick, fragmented, almost punk-like ways of working.

LATE STYLE?

Did Munch develop his own characteristic 'late style'?[16] In recent decades the term has taken root as a separate category within art, describing works created by artists at an advanced age, and which differ from their earlier artistic endeavours. Traditionally, such works have been written off as a less interesting aspect of an artist's overall oeuvre, but more recently they have become a subject of greater interest. The Renaissance painter Titian's late, almost colourless works, and Beethoven's last string quartets, are often held up as examples of this – to these we can add Monet's paintings of waterlilies, and Matisse's so-called 'cutouts'. The notion of a 'late style' is often based on the idea that any pronounced changes in living conditions have an impact on the work that an artist produces. Changes in lifestyle, situation and circumstances in old age thus become an explanation for an artist's changes in aesthetic sensibility. Titian's eyesight deteriorated towards the end of his life; Beethoven lost his hearing. Monet withdrew to his gardens in Giverny, and Matisse became bound to a wheelchair. But to what extent do these circumstances explain the changes apparent in the artists' later works? This is part of what the discussion surrounding 'late style' is about. Munch also developed something new and distinctive in the works he produced towards the end of his life, but they do not entirely break with what he had created earlier.

Jealousy Motif, 1929–30, oil on canvas, 110 × 100 cm.

Rather, the works are about elaborating on and refining central aspects of his work in general, such as deeper explorations of the unfinished, the articulation of shapes as uniform fields of colour, or permitting the almost bare canvas to remain visible and take on the painting's starring role.

NAZISM

After his eye disease in 1930, Munch increasingly withdrew into Ekely. He made fewer trips, and many knocked on his door in vain. Out in the wider world, things were getting worse, and the situation was particularly difficult in Munch's second homeland of Germany. After the National Socialists came to power in 1933, many of Munch's closest friends and contacts encountered significant problems. Many of them were Jews and radical leftists, and belonged to the part of society's intellectual elite that the Nazis were keen to eradicate. In Berlin, Munch's most loyal friend and supporter Ludwig Justi was forced to leave his position as director of the National Gallery. To start with, the Nazis argued about which works of art should represent the supreme Germanic culture. Some were keen on the expressionist movement of which Munch was now a part, but more traditional ideals prevailed, and a smouldering hatred of modern art was instead institutionalized. Munch's works were among the many that were now branded undesirable, and purged from Germany's museums. In 1937 the Degenerate Art exhibition was arranged, in which works of modern art were presented as laughing stocks, examples of cultural decline. The seized works were mostly sold abroad, and many of Munch's paintings ended up in Norwegian hands through auctions in Oslo. Paradoxically enough, the Nazi regime earned significant sums of money by ridding itself of art it deemed to be of poor quality and detrimental to the nation.

In Norway, the situation was a different one. In fact, the occupying Nazi forces attempted use Munch's works as an example of the precedence of Germanic culture – but without success.

In 1943, when the National Gallery's new Nazi-sympathizing director Søren Onsager took the initiative to arrange a large exhibition in connection with Munch's eightieth birthday, Munch declined. He was no active resistance fighter, but nor would he permit himself to be used by the regime.

Munch rarely expressed his opinions on political matters, but unlike Hamsun he did not support the developments taking place in Germany. He generally preferred to support those who rebelled, and sympathized with radical, revolutionary movements such as the one that took place in Russia in 1917. He was also part of a circle that took an extremely critical position on the Nazis' actions.[17]

ON THE THRESHOLD

Over the course of Munch's time at Ekely period he produced a wide array of self-portraits, executed as drawings, prints, photographs, films and paintings. These images exhibit qualities of introspective investigation, authentic study and formal experimentation, but they can also seem like dramatic stagings of the self: the lonely man in the large, desolate room, or in vigorous form outdoors with a brush and palette, squinting towards the piercing sun. In other works Munch catches himself on the move, wearing a hat and coat. From the very start of his painting career, Munch had followed the great tradition stemming from Rembrandt and Goya, by studying himself in his works.

The painting *Self-Portrait. Between the Clock and the Bed* (overleaf) would be one of Munch's last. Yet again, we are beside a bed. Simple, vertical lines dominate the image, contrasting with the horizontal bed covered by a striking blanket in red, black and white. Like a thin, vertical pole Munch has placed himself, in full figure, a little way into the room between the clock and the bed. The grandfather clock lacks hands, and the bed suggests eternal rest: we are presented with an old man nearing the end of his life. The artist is also standing between two rooms, as if on the periphery, or at a threshold. Further in we can sense yet

another room, this one in darkness. It is as if we are peeking around a corner at something unknown, something inaccessible to us. The blanket's bold pattern, rough, precise brushstrokes against a bright, white fabric, stands out as an almost separate abstract image within the image. Other paintings are also hanging in the background, naturally enough – we are, after all, in the home of a visual artist. These include a mirror-image of Munch's painting *Krotkaya* from the late 1920s, created together with his favourite model, Birgit Prestøe. Krotkaya was a sympathetic, tragic figure in one of Dostoevsky's short stories who took her own life.[18]

RIPPLE EFFECTS

In December 1943, one of the occupying forces' largest munition depots situated by the Port of Oslo exploded, shattering windowpanes across the entire city – including at Ekely. It became cold in the yellow house, and Munch caught a severe chill. According to Inger Munch, the only one of Munch's four siblings to outlive the artist, Munch portrayed his situation as a convalescent in *Self-Portrait by the Arbour* (overleaf), depicting himself as an aloof, anonymous figure walking out in the garden.[19] On 23 January 1944, just over a month after his eightieth birthday, Munch died peacefully with his housekeeper of many years, Liv Berg, at his side. In his will, Munch unconditionally granted all works currently in his possession, as well as various other materials, to Oslo municipality. Around 1,100 paintings, 18,000 prints, 4,500 watercolours and drawings, 6 sculptures, a huge number of letters, notebooks and records, as well as a library, thereby came into public ownership.

Immediately after the Second World War, Munch was celebrated as the country's uncontested pioneer of the new, modern art, and as early as that same summer the National Gallery was able to exhibit Munch's bequest. The exhibition filled the gallery's first floor, and director Johan Langaard was so overcome that he encouraged anyone and everyone to

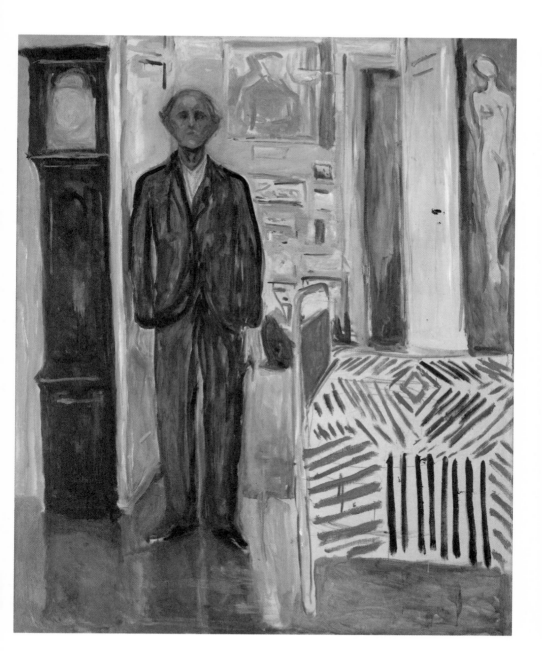

Self-Portrait. Between the Clock and the Bed, 1940–43, oil on canvas, 149.5 × 120.5 cm.

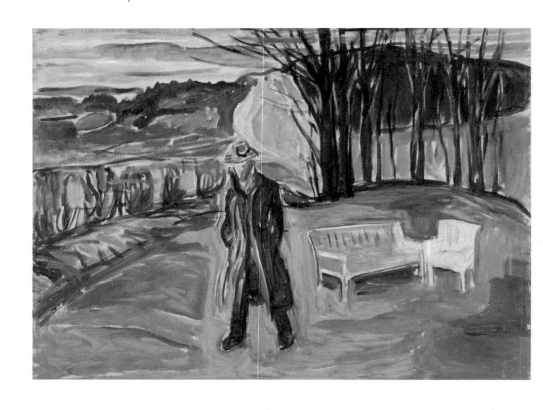

Self-Portrait by the Arbour, c. 1943, oil on canvas, 60 × 80 cm.

The Munch Museum, Oslo, 1963.

spend their summer holiday visiting the gallery. The exhibition remained on display for over half a year – the public flocked to the premises, and Oslo municipality decided to establish a dedicated museum for Munch's works. The Munch Museum was opened in May 1963 – one hundred years after the artist's birth.

Overseas, Munch was rehabilitated following the Second World War, and his works once again revered as modern classics. In the USA, a substantial travelling exhibition arranged by New York's Museum of Modern Art opened in 1950, and in Europe the first cutting-edge *documenta* exhibition took place in Kassel in 1955, re-establishing modern art's position as dominant and important. This was especially true for Munch and the German expressionists, who were richly represented.

At the time of his death, Munch owned three properties: Ekely, Nedre Ramme in Hvitsten, and the old fisherman's cottage in Åsgårdstrand. All have been preserved, but most authentic is probably the one in Åsgårdstrand. The house Munch rented in Warnemünde, Am Strom 53, has also been converted into Edvard Munch Haus, and contains apartments for artists and art students.

The Skrubben property in Kragerø – where he developed the concepts for the university Aula's decorative scheme – burned down in 1939. The yellow villa at Ekely was demolished in 1960, but the winter studio and parts of the garden remain intact. Oslo municipality acquired areas of the site after the war, and established housing for artists here.

In a photograph that was taken in 1938 in connection with his seventy-fifth birthday, Munch is sitting in the winter studio surrounded by his paintings. The works hang and stand haphazardly about the room, without gold frames or any other such adornments. It seems almost as if Munch never actually worked in the studio, but instead used it only as an exhibition space. This slightly lopsided, careless aesthetic is typical of Munch, but the mounting of the images also highlights his ambition that his paintings should be viewed in relation to each other. At long last, Munch's dream to gather many of his works into a unified *Frieze of Life* was, in a way, realized.

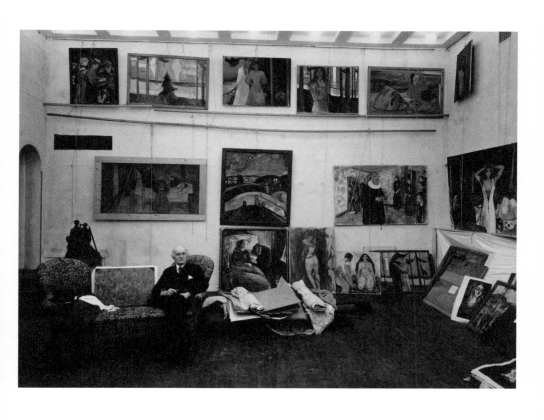

Edvard Munch in the winter studio at Ekely.
Photograph taken in connection with his seventy-fifth birthday in 1938.

AFTERWORD

MUNCH'S OEUVRE WAS RICH, diverse and complex. Not
everything he did found favour with everyone, but some of
his works have clearly had a huge impact on many. So where
does his work sit within the history of art? One of the reasons
that Munch's works are still subject to such a degree of scholarly
research and debate, and exhibited around the world, is that his
position within the story of modern art and its breakthrough
at the turn of the century is somewhat unclear. He was written
into this history as a central, groundbreaking figure for expres-
sionism in the visual arts at an early stage, but nevertheless
seems to have ended up slightly on the sidelines of events as
they unfolded. In a way, he is both a canonized master and an
outsider – simultaneously part of the scene and ostracized.[1]

So why does Munch occupy this somewhat murky posi-
tion? There are many facets to this question, some of which
originate with the paintings themselves, and some with the
way in which the story of modern art has been written. Munch
went to great lengths to explore each medium's distinctive
means as something expressive in itself. In particular, he
showed a radical interest in what was special about painting
as a medium, and in how different printing techniques created

distinctive expressions. In many cases, the very act of painting, visible in the work's physical materiality, became the painting's dominating feature. But the subject remained important to Munch. He worked abstractly, but not with pure abstraction. He therefore fell both within and outside this trend in modern art. The work's execution and materiality prevailed as more important than the subject and to what the image referred. The ideal became an image that was cleansed of superficial or external conventions such as motifs, symbols, literary influences, frames and stimulating titles.

The conditions for this understanding were established during the periods prior to and following the Second World War – it was then that the line was drawn in earnest by artists such as Edouard Manet and the impressionists in the lead up to the birth and age of abstract art. The perspective pointed to the post-war abstract expressionists. Although Munch has much in common with these artists from a painterly perspective, he fell outside the confines of modernism's reductive formalism. His paintings did not quite fit in when this larger history was written, but on the other hand this has created fertile ground for a strong renewed interest in his work in our time. The examination of modernism's narrow historical understanding has brought Munch into a broader discussion about the epoch's artistic development, and what it was about.

Clement Greenberg, one of modernism's most influential theorists, examined Munch's undetermined status in one of his essays.[2] Despite the fact that Munch's works were both figurative and sometimes literary, Greenberg had to admit that the paintings made a profound impression. Why? Perhaps the answer may lie in the fact that Munch attempted to paint moods and emotions, allowing them to dominate his works. While his subjects played a role in establishing these elements, his enduring appeal rests in his exploration of painting itself as an abstract language, which lead him to present familiar subjects in new ways.

ACKNOWLEDGMENTS

Gerd Woll's catalogues of Munch's prints and paintings have been a crucial prerequisite for the writing of this book, as have the Munch Museum's online publications of Munch's texts and drawings under the leadership of Mai-Britt Guleng and Magne Bruteig, respectively. These sources enable anyone to explore Munch's oeuvre from anywhere in the world. The following bibliography lists other material I have consulted.

My aim has been to produce an accessible presentation of Munch as an artist, with an emphasis on his works. Enormous thanks are due to the many people who have contributed to my work – most of them without even realizing they were doing so. It is impossible to name everyone with whom I have discussed Munch over the years, and so I would rather mention no specific names than neglect to include anyone. There are, however, certain individuals and institutions to whom I would like to extend special thanks, since they have contributed more concretely to the realization of this book. Gerd Woll, Wenche Volle, Jon-Ove Steihaug and Karen E. Lerheim have generously commented on the text, and this has been hugely valuable. Many thanks to the Munch Museum, Oslo, and its director, Stein Olav Henrichsen, and to the National Museum, Oslo, and its director, Karin Hindsbo. All errors and omissions are of course my own.

Last, but not least, a huge thank you to Jorunn Sandsmark, Guro Solberg and Erling Kagge at J. M. Stenersens Forlag and Kagge Forlag for their initiative and faith in the project, and for the enriching collaboration we have sustained throughout the writing of this book.

CONSULTED LITERATURE AND SOURCES

Edvard Munch's Writings: https://www.emunch.no/english.xhtml
The MM N number refers to the specific source.
Catalogue of Edvard Munch's drawings: http://munch.emuseum.com/

Jens Thiis: *Edvard Munch og hans samtid* (Oslo: Gyldendal, 1933).
Rolf E. Stenersen: *Edvard Munch: Close-Up of a Genius* (Oslo: Gyldendal, 1969).
 This book was first published in Stockholm in 1944, and has since
 been published in many languages and editions.
Ingrid Langaard: *Edvard Munch: Modningsår* (Oslo: Gyldendal, 1960).
Ragna Stang: *Edvard Munch: The Man and His Art* (New York: Abbeville Press,
 1979). This book was first published in 1977.
Edvard Munch: Symbols & Images. Exh. cat. (Washington, D.C.: National Gallery
 of Art, 1978).
Arne Eggum: *Edvard Munch: Paintings, Sketches, and Studies* (Oslo:
 J. M. Stenersens Forlag, 1984).
Ulrich Bischoff: *Edvard Munch 1863–1944: Images of Life and Death* (Cologne:
 Taschen, 1988). This book is published in many languages and editions.
Gerd Woll: *Edvard Munch: The Complete Graphic Works* (London: Philip Wilson
 Publishers, 2001).
Magne Bruteig: *Munch: Drawings*. Exh. cat. (Brussels/Oslo: Musée d'Ixelles/
 Munch Museum, 2004).
Atle Næss: *Munch. En biografi* (Oslo: Gyldendal, 2004).
Iris Müller-Westermann: *Munch by Himself*. Exh. cat. (Stockholm/Oslo/
 London: Moderna Museet/Munch Museum/Royal Academy of Arts,
 2005).
Erik Mørstad (ed.): *Edvard Munch. An Anthology* (Oslo: Unipub, 2006).
Mai Britt Guleng and Ingebjørg Ydstie (eds): *Munch Becoming 'Munch': Artistic
 Strategies 1880–1892*. Exh. cat. (Oslo: Munch Museum, 2008).
Jay A. Clarke: *Becoming Edvard Munch: Influence, Anxiety, and Myth* (Chicago:
 Art Institute of Chicago/Yale University Press, 2009).
Gerd Woll: *Edvard Munch: Complete Paintings I–IV* (London: Thames & Hudson,
 2009).
Mai Britt Guleng (ed.): *eMunch.no – Text and Image*. Exh. cat. (Oslo: Munch
 Museum, 2011).
Angela Lampe and Clément Chéroux (eds): *Edvard Munch: The Modern Eye*.
 Exh. cat. (London: Tate Publishing, 2012).
Magne Bruteig and Ute Kuhlemann Falck: *Edvard Munch: Works on Paper*.
 Exh. cat. (Oslo/Brussels: Munch Museum/Mercatorfonds, 2013).
Mai Britt Guleng, Birgitte Sauge and Jon-Ove Steihaug (eds): *Edvard Munch
 1863–1944*. Exh. cat. (Oslo/Milan: Munch Museum/National Museum/
 SKIRA, 2013).
Erik Mørstad: *Edvard Munch: Formative år 1874–1892. Norske og franske impulser*
 (Oslo: University of Oslo, 2016).
Karl Ove Knausgård: *So Much Longing in So Little Space: The Art of Edvard Munch*
 (London: Penguin Random House, 2019).

NOTES

Kristiania in the 1800s

1 This painting is one of Munch's most
 discussed and analysed. For more
 recent literature, see Tone Skedsmo:
 'Tautrekkingen rundt Det syke barn',
 Kunst og Kultur (Oslo: Universitetsforlaget,
 1985), pp. 184–95; Jay A. Clarke:
 'Originality and repetition in Edvard
 Munch's The Sick Child' and Øivind
 Storm Bjerke: 'The Sick Child: form as
 content', both in Mørstad (2006); Lasse
 Jacobsen: 'Edvard Munch's photograph
 album from Atelier Marschalk, Berlin
 1892–93 – and "The sick child"', *Munch
 Becoming 'Munch'* (2008), pp. 199–206;
 *Edvard Munch: The Sick Child. The Story of a
 Masterpiece* (Oslo: The National Museum,
 2009), with texts by Trond Aslaksby and
 Øystein Ustvedt. The painting is also
 central to two recent doctoral theses:
 Stian Grøgaard: *Edvard Munch: Et utsatt
 liv* (Bergen: University of Bergen, 2013);
 Gustav Jørgen Pedersen: *On the Pictorial
 Thinking of Death* (Oslo: University of
 Oslo, 2017).

2 The painting was damaged and the left
 side repaired by Munch in the mid-1890s,
 see Aslaksby (op. cit.), p. 59.

3 In 1925 the city officially resumed its
 former name, Oslo.

4 Munch Museum MM N 3103.

5 Inger Munch (ed.): *Edvard Munchs brev:
 familien* (Oslo: Grundt Tanum, 1949), p. 47.

6 The term was used in the 1883 census, see
 Magne Bruteig: 'Unpainted drawings',
 Munch Becoming 'Munch' (2008), pp. 63–83.

7 In their own time, artists such as
 Krohg and Thaulow were referred
 to as 'naturalists'. Today, the term
 'naturalism' is often associated with a
 more extreme form of realism, and this
 account therefore uses the term 'realists'.

8 The quotation stems from Emile Zola's art
 criticism from the 1860s onwards.

9 The motto was an abbreviated version
 of a quotation from Edouard Manet: 'I
 paint what I see and not what others like
 to see' ('je peins ce que je vois et non ce
 qu'il plaît aux autres de voir'). Later in life
 Munch took yet another approach, when
 he wrote: 'I do not paint what I see, but
 what I saw'. *Livsfrisens tilblivelse* (1919), p. 1.
 Translated by Francesca M. Nichols.

10 Thaulow was Munch's third cousin. In
 1884 he purchased the painting *Morning*
 (1884), and contributed a stipend that
 made it possible for Munch to travel to
 Antwerp and Paris the following year.

11 Erik Werenskiold: 'Impressionisterne',
 Nyt Tidsskrift (Kristiania, 1882),
 pp. 229–34.

12 A painting by Thomas Couture was
 already on display at the National
 Gallery. Manet was one of Krohg's
 greatest artistic heroes.

13 Quoted in Thiis (1933), p. 106.

14 *Livsfrisens tilblivelse* (1929), pp. 9–10. In a
 draft letter dated 1934: 'It is perhaps my
 most important painting and in any case
 my breakthrough as an... expressionistic
 painter', Munch Museum MM N 1950.

15 Munch Museum MM N 3120.

16 Andreas Aubert, *Morgenbladet* 9 November
 1886. For a discussion of Munch and
 his critics throughout the 1880s, see
 Nils Messel: 'Edvard Munch and his
 Critics in the 1880s', *Kunst og Kultur* (Oslo:
 Universitetsforlaget, 1994), pp. 213–27.

17 During the interwar period the historical-
 biographical method came to dominate
 the study and understanding of
 artists' works. In the literature about
 Munch, Rolf E. Stenersen's book
 Edvard Munch. Close-Up of a Genius in
 particular contributed to a biographical
 understanding of Munch's works.

18 *Livsfrisens tilblivelse* (1929), p. 9. Translated
 by Francesca M. Nichols.

19 In *Die Geschichte der Kunst im 20. Jahrhundert:
 von den Avantgarden bis zur Gegenwart*
 (Munich: Beck, 2001), German art
 historian Uwe Schneede places great
 emphasis on *The Sick Child* in relation
 to early modernism.

20 For a review of the motif and various
 versions of it, see *Edvard Munch: Puberty*
 (Oslo: Munch Museum/Orfeus, 2012).

Texts by Jay A. Clarke, Finn Skårderud, Biljana Topalova-Casadiego and Ingebjørg Ydstie.

21 For a discussion of Munch's drawings, see Bruteig (2004) and Bruteig/Falck (2013). The Munch Museum has published a collated overview of Munch's drawings, with texts by Bruteig: http://munch.emuseum.com

22 Letter to Sigurd Høst 1922, Munch Museum MM N 3246.

23 A number of artists participated in the Autumn Exhibition of 1886 with paintings created during the summer at Fleskum Farm in Bærum. They placed greater emphasis on the dusk light, unusual perspectives and atmospheric motifs than previously, such as in the paintings of Kitty Kielland and Erik Werenskiold.

24 Christian Krohg: 'Tredie Generation', VG 27 April 1889.

25 The paintings Morning and Inger on the Beach were later acquired by Rasmus Meyer in Bergen, and are now part of Rasmus Meyer's Collection at KODE. Ownership of The Sick Child was unclear for many years, resulting in a conflict that went all the way to the Supreme Court. In 1930, the painting ended up at the National Gallery in Oslo when Oda Krohg exchanged the work with a later version, which at the time was included in Olaf Schou's significant gift to the gallery. See Skedsmo (op. cit.).

From the Modern Life of the Soul (1890–1900)

1 An account of Munch's relationship with Paris and France is given in the exhibition catalogue Munch et la France (Paris/Oslo: Musée d'Orsay/Munch Museum, 1991), particularly in the texts by Arne Eggum and Rodolphe Rapetti. For a more detailed discussion of Rue Lafayette, see Patricia Berman: 'The urban sublime and the making of the modern artist', Munch Becoming 'Munch' (2008), pp. 139–57.

2 Munch Museum MM N 289 dated 1889–90, and MM N 63 dated 1929 (last section quoted). Translations by Francesca

M. Nichols. The text exists in several versions composed at different times. For a discussion of the text and its various versions, see Munch et la France (1991), pp. 341–49, and Wenche Volle: Munchs rom, PhD thesis 54 (Oslo: Oslo School of Architecture and Design, 2012), pp. 217–34.

3 The term 'symbolism' is often used about the art of the 1890s. Even though the works referred to often point in the direction of simplification, stylization and anti-naturalism, the point was not so much about any formal common aspects, but rather about the ambition to portray other dimensions beyond the visible. A strong interest in mystical, occult and spiritual phenomena is part of this, in addition to the use of myths, dreams, symbols, and fantastical notions.

4 Munch writes in retrospect about his interest in the new, electric light in the capital: 'I was once again out on the blue Boulevard des Italiens – with the white electric lamps and the yellow gas lights – with the myriad unfamiliar faces that appeared so ghostly in the electric light.' Livsfrisens tilblivelse (1929), p. 7. Translated by Francesca M. Nichols.

5 Munch used the motif several times, in paintings, pastels and lithographs. Which of the two versions of the paintings was created first has been the subject of much debate, but there is much to indicate that the National Museum's version came first. It has a more preliminary quality to it, as well as a number of peculiarities, such as the vertical plank shape to the right. There is also a sketch on the back – probably a first attempt. The version held by the Munch Museum is more assured in its execution, and stylistically has more in common with what Munch was producing fifteen years later. For a discussion of the dating, see Marit Lange: 'Skrik nok en gang: kontra-faktisk kunsthistorie', Kunst og Kultur (Oslo: Universitetsforlaget, 2005), pp. 240–53. There are countless discussions of

The Scream from a variety of thematic perspectives and approaches. Three publications that provide an overview must be mentioned here: Reinhold Heller: *The Scream* (New York: The Viking Press, 1973); *The Scream* (Oslo: Munch Museum/Vigmostad & Bjørke, 2008); Bjarne Riiser Gundersen/Poul Erik Tøjner: *Skrik. Historien om et bilde* (Oslo: Press Forlag, 2013).

6 Munch Museum MM T 2785, pp. 72–73, note dated 1908. Translated by Francesca M. Nichols.

7 *Das Werk des Edvard Munch – vier Beiträge* (Berlin: Fischer Verlag, 1894). The text is translated into English in Trine Otte Bak Nielsen (ed.): *Vigeland+Munch: Behind the Myths*. Exh. cat. (Oslo: Munch Museum, 2016), pp. 81–91. For a discussion of Przybyszewski's interpretation, see Øivind Storm Bjerke: 'The Scream as Part of the Art Historical Canon', *The Scream* (2008), pp. 13–55.

8 For a discussion of the Madonna motif, see Frank Høifødt: 'Munch's Madonna – Dream and Vision', *Madonna* (Oslo: Munch Museum/Vigmostad & Bjørke, 2008).

9 These were added to the motif both in an earlier, lost version of the painting, and in later etchings (1894) and lithographs (1895/1902).

10 See Clarke (2009), p. 126.

11 This theme recurs in many of Sigmund Freud's texts about male sexuality and men's relationships to women, most thoroughly in *Drei Abhandlungen zur Sexualtheorie* (Three Essays on the Theory of Sexuality), 1905.

12 *Berliner Tageblatt*, 8 November 1892. Cited in Næss (2004), p. 133.

13 Letter to Aunt Karen dated 17 November 1892, Munch Museum MM N 786.

14 The tavern was called G. *Türkes Weinhandlung und Probierstube*, and renamed *Zum schwarzen Ferkel* by Strindberg.

15 Przybyszewski (1894). In addition to Przybyszewski, Meier-Graefe, Franz Servaes and Willy Pastor also contributed texts.

16 Julius Meier-Graefe: *Entwicklungsgeschichte der modernen Kunst* (Stuttgart: Jul Hoffmann, 1904).

17 *Edvard Munch: Livsfrisen* (Kristiania: Blomqvist, 1919), p. 2. Translated by Francesca M. Nichols. For a review of the two texts Munch wrote about the frieze, see Lasse Jacobsen: 'Livsfrisen og Livsfrisens tilblivelse – kunstneren griper til sverdet og pennen', *Edvard Munchs Livsfrise: En rekonstruksjon av utstillingen hos Blomqvist 1918*. Exh. cat. (Oslo: Munch Museum, 2002), pp. 62–66. The topic is also discussed in a great many other contexts. For a review of its development and ideas, see Mai Britt Guleng: 'The Narratives of The Frieze of Life. Edvard Munch's Picture Series', *Edvard Munch: 1863–1944* (2013), pp. 128–39.

18 The description of the series' context and development forms the basis for most interpretations of *The Frieze of Life*, and can be traced back to Stanisław Przybyszewski: *Das Werk des Edvard Munch* (1894), under the title 'Love'.

19 Patricia Berman has analysed this painting in detail: 'Edvard Munch's Self-Portrait with a Cigarette: Smoking and the Bohemian Persona', *The Art Bulletin* (London, 1993), pp. 627–46.

20 For a discussion of Munch's processes and the use of turpentine, see Mille Stein: 'Patterns in Munch's Painting Technique', *Edvard Munch: Between the Clock and the Bed*. Exh. cat. (New York: The Metropolitan Museum, 2017), pp. 31–43.

21 Munch Museum MM N 29, note thought to be from 1890–92. Translated by Francesca M. Nichols.

22 This was discussed by Clement Greenberg, one of modernism's foremost theorists within the visual arts, most clearly in the essay 'Modernist Painting', 1960.

23 Munch Museum MM N 29, thought to be from 1890–92. Translated by Francesca M. Nichols.

24 For a review of Munch as a graphic artist, see Woll (2001).

25 For a review of the kiss motif, see Trine Nordkvelle: 'Reading the Repeated Kiss. A Narratological Experiment', *Edvard Munch: 1863–1944* (2013), pp. 264–71.

26 The first volume was published in 1907: *Gustav Schiefler: Verzeichnis des graphischen Werks Edvard Munchs bis 1906* (Berlin: Bruno Cassirer, 1907).

27 The question of whether the girls are standing on a bridge or a jetty has plagued the painting for many years. In Munch's time, there was a bridge at this location which led out to a dock. The dock was reconstructed and modernized, hence: *The Girls on the Bridge*.

28 *September* attracted significant attention at the Autumn Exhibition of 1883. It was acquired by the National Gallery the following year, and quickly became one of the museum's most popular works under the title *From Telemark*.

The Artistic Renewal (1900–1916)

1 The changes in Munch's art around 1905 and his subsequent late works have attracted significant attention in recent decades; see Elizabeth Prelinger: *After the Scream: The Late Paintings of Edvard Munch* (Atlanta: High Art Museum, 2002); L. A. Körber: 'Munch and Men: Work, Nation, and Reproduction in Edvard Munch's Later Works', Mørstad (2006), pp. 163–78; Gunnar Sørensen: 'Vitalismens år', *Livskraft. Vitalismen som kunstnerisk impuls 1900–1930*. Exh. cat. (Oslo: Munch Museum, 2006), pp. 13–41; Patricia Berman: 'The Many Lives of Edvard Munch', Gerd Woll (2009), pp. 1277–80; Rune Slagstad: 'Munchs kropp', *(Sporten). En idéhistorisk studie* (Oslo: Pax Forlag 2008), pp. 417–56; Hilde Rognerud: 'Zarathustra-Nietzsche med vinger. Edvard Munch maler samtidens motefilosof', *Kunst og Kultur* (Oslo: Universitetsforlaget, 2011), pp. 146–59.

2 Max Linde: *Edvard Munch und die Kunst der Zukunft* (Berlin: Gottheiner, 1902).

3 Letter to Karen Bjølstad, Munch Museum MM N 926, dated 1907.

4 Max Linde in a letter from 1906, Munch Museum MM N 2334; Arne Eggum (ed.): *Gustav Schiefler. Briefwechsel. Band 1 1902–1914* (Hamburg: Verein für Hamburgische Geschichte, 1987), p. 208.

5 This is discussed in detail in three publications: Arne Eggum: *Munch and Photography* (New Haven and London: Yale University Press, 1989); Cecilie Tyri Holt: *Edvard Munch. Fotografier* (Oslo: Press Forlag, 2013); Angela Lampe and Clément Chéroux: '"Write your life": Photography and Autobiography', *Edvard Munch: The Modern Eye*. Exh. cat. (London: Tate Publishing, 2012), pp. 56–63.

6 Hans Törsleff: 'Edvard Munch – der Einsliedler von Ekely', *Die Dame*, no. 4, November 1930, pp. 7–9, 42, 43; Eggum (op. cit.), p. 181; Holt (op. cit.), p. 74.

7 Meier-Graefe (op. cit.).

8 The literature about Munch's decoration of the Aula ceremonial hall is extensive. Three particularly important publications are: Petra Pettersen: 'Munch's Aula Paintings', Woll (2009), pp. 829–51; Ingebjørg Ydstie: 'Munch's Aula Decorations and the National Project', *Munch's Laboratory: The Path to the Aula*. Exh. cat. (Oslo: Munch Museum, 2011), pp. 79–107; Peder Anker and Patricia G. Berman (eds): *Edvard Munchs Aulamalerier. Fra kontroversielt prosjekt til nasjonalskatt* (Oslo: Messel Forlag, 2011).

9 For a discussion of Munch's years in Kragerø, see Hans-Martin Frydenberg Flaatten: *Sunrise in Kragerø: The Story of Edvard Munch's Life at Skrubben 1909–1915* (Oslo: Sem & Stenersen Forlag, 2013).

10 Peter Andreas Munch (1810–1863) helped to establish history as an independent academic subject in Norway. He was a professor at the University of Oslo and the author of works including *Det norske folks historie*. In 1933, a sculpture of P. A. Munch was erected in Universitetsplassen, right outside the university's Aula building.

11 *Livsfrisen* (Kristiania: Blomqvist, 1918), p. 3.

Ekely (1916–1944)

1 Munch's Ekely period is discussed in detail in the exhibition catalogue *Munch og Ekely 1916–1944* (Oslo: Munch Museum/

Labyrinth Press, 1998), with texts by Arne Eggum, Gerd Woll and Petra Pettersen.

2 The National Gallery's accounting overview, 1903–1922 RA/L0004. Munch's acquisition of the house in Åsgårdstrand started in 1910, when he acquired the Nedre Ramme farm in Hvitsten. In 1918, he also purchased Ålerud farm in Vestby, which he sold in 1922.

3 Cited in Jens Thiis (1933), p. 292.

4 For an in-depth review of Munch's paintings of workers and monumental projects, see Gerd Woll: 'From the Aula to the City Hall: Edvard Munch's Monumental Projects 1909–1930', Edvard Munch: Monumental Projects 1909–1930. Exh. cat. (Lillehammer: Lillehammer Art Museum, 1993), pp. 8–105.

5 Jappe Nilssen, Dagbladet, 19 February 1918.

6 The term 'kill-or-cure remedy' ('hestekur' in Norwegian) has been much discussed and contested. The central texts are: Jan Thurmann-Moe: Edvard Munchs hestekur. Eksperimenter med teknikk og materiale (Oslo: Munch Museum, 1995); Dieter Buchhart: 'Edvard Munch. Disappearance – Experiments with material and motif', Edvard Munch: Theme and Variation. Exh. cat. (Vienna/Ostfildern: Albertina Museum/Hatje Cantz, 2003); Mille Stein: 'Edvard Munch og "hestekuren". En revurdering', Kunst og Kultur, no. 1/2 2017, pp. 48–74. According to Stein, the term was first used by Rolf E. Stenersen in the book Edvard Munch: Close-Up of a Genius.

7 Morgenbladet, 19 July 1945, quoted in Mille Stein (op. cit.), note 4.

8 Artists such as Judit Reigl, Anselm Kiefer, Bjarne Melgaard, Fredrik Værslev and Ragna Bley have explored the impact of the surroundings and interaction in the painting process.

9 This topic is discussed in the exhibition catalogue Edvard Munch and His Models 1912–1944 (Sapporo: Sapporo MoMA, 1992), with texts by Arne Eggum and Bodil Stenseth.

10 In the years following Munch's death, several of Munch's models and others published texts about subjects including this relationship. All stress that he paid well and treated the models with the utmost respect and decorum. See for example Birgit Prestøe's account: 'Minner om Edvard Munch', Edvard Munch som vi kjente ham. Vennene forteller (Oslo: Dreyers Forlag, 1946), pp. 100–106.

11 For more about Prestøe, see Bodil Stenseth: Modellen (Oslo: Aschehoug, 1988).

12 Edvard Munch: Livsfrisen (1919); Edvard Munch: Livsfrisens tilblivelse (1929). Translated by Francesca M. Nichols.

13 Pola Gauguin: Edvard Munch (Oslo: Aschehoug, 1933); Jens Thiis: Edvard Munch og hans samtid (Oslo: Gyldendal, 1933).

14 Munch discusses Ibsen's visit to his exhibition at Blomqvist in 1895 in several letters and notes: 'One day I met Ibsen down there – He walked over to me – I find it extremely interesting he said – Believe me – you will have the same fate as I – the more enemies [you make] the more friends [you will acquire]', Munch Museum MM N 77, dated 1928–29. Translated by Francesca M. Nichols.

15 In Woll's catalogue of Munch's paintings the work is listed under 'records and fragments' (Woll, 2009). It was first exhibited at the exhibition 'Towards the Forest – Knausgård on Munch' at the Munch Museum in 2017.

16 For a discussion of the phenomenon, see McMullan/Smiles (eds): Late Style and its Discontents (Oxford: Oxford University Press, 2016).

17 Cf. undated letter from Jens Thiis: 'But he (Hitler) and the others have gone mad, become dangerous, raging beasts. Can one therefore defend them? Not me. With their insane persecution of the Jews they have eradicated almost all higher intelligence in Germany, scientists, authors, artists, musicians, actors and the leading members of the press', Munch Museum MM K 1170.

18 Fyodor Dostoevksy: A Gentle Creature and Other Stories (Oxford: Oxford University Press, 1995). The story A Gentle Creature ('Krotkaja') was first published in 1876.

Krotkaya is a proper name, but also means 'the cheerful', 'the gentle', 'the pious'.

19 According to Inger Munch, the painting was created the day after the large explosion at Filipstad, Aftenposten, 12 July 1945.

Afterword

1 For a discussion of Munch's place in art history, see Richard Schiff: 'Munch on the Periphery', *Edvard Munch: Between the Clock and the Bed*. Exh. cat. (New York: The Metropolitan Museum, 2017), pp. 59–72.

2 Munch is discussed in 'Complaints of an Art Critic', reproduced in *Clement Greenberg: The Collected Essays and Criticism* (Chicago: The University of Chicago Press, 1993), pp. 271–72. The text was first printed in 1967.

PICTURE CREDITS

Page 71, bottom left: National Museum
NG.M.00939VERSO.GW 333. Photo ©
Børre Høstland, National Museum of Art,
Architecture and Design.
Page 71, right: Munch Museum MM G 193-1.
GW-gr.38. Photo © Munch Museum.
Page 72: Munch Museum MM.M.00514.
GW 896. Photo © Munch Museum.
Page 75: Munch Museum MM.M.00068.
GW 365. Photo © Munch Museum.
Page 76, left: Munch Museum MM G 196.
GW-gr.42. Photo © Munch Museum.
Page 76, right: Munch Museum MM G 197.
GW-gr.43. Photo © Munch Museum.
Page 77: Munch Museum MM G 194.
GW-gr.39-I. Photo © Munch Museum.
Page 79: Photo: Max Marschalk. Munch
Museum archives MM B 1029.
Page 80: Munch Museum MM G 219.GW-gr.
66-III.Photo © Munch Museum.
Page 81: Munch Museum MM.M.00134.
GW 383. Photo © Munch Museum.
Page 82: Munch Museum MM.M.00212.
GW 337. Photo © Munch Museum.
Page 83: National Museum NG.M.00941.
GW 464. Photo © Børre Høstland/National
Museum of Art, Architecture and Design.
Page 84: Munch Museum MM.M.00419.
GW 428. Photo © Munch Museum.
Page 88, top: Munch Museum MM.T.00133-22-
verso. Photo © Munch Museum.
Page 89: Munch Museum MM.M.00292.
GW 335. Photo © Munch Museum.
Page 90: Unknown photographer. Munch
Museum archives MM.B.01101.
Page 93: National Museum NG.M.00470.
GW 382. Photo © Børre Høstland/National
Museum of Art, Architecture and Design.
Page 94: National Museum NG.M.00940.
GW 329. Photo © Børre Høstland/National
Museum of Art, Architecture and Design.
Page 95: Munch Museum MM G 586.
GW-gr. 130. Photo © Munch Museum.
Page 97: Munch Museum MM G 18. GW-gr. 12-I.
Photo © Munch Museum.
Page 100: Munch Museum MM G 21. GW-gr. 23.
Photo © Munch Museum.
Page 101: Munch Museum MM G 580.
GW-gr. 204 II. Photo © Munch Museum.
Page 102: Munch Museum MM G 593.
GW-gr. 117-IV. Photo © Munch Museum.

Page 103: Munch Museum MM G 601.
GW-gr.157-II. Photo © Munch Museum.
Page 104: Munch Museum MM G 255.
GW-gr. 244-II. Photo © Munch Museum.
Page 105: Munch Museum MM G 192.
GW-gr.37-III. Photo © Munch Museum.
Page 106: Munch Museum MM G 630.
GW-gr. 419. Photo © Munch Museum.
Page 107: Munch Museum MM G 203.
GW-gr. 72-III. Photo © Munch Museum.
Page 108: Munch Museum MM G 707.
GW-gr. 746. Photo © Munch Museum.
Page 110: National Museum NG.M.02815.
GW 381. Photo © Jacques Lathion/National
Museum of Art, Architecture and Design.
Page 113: National Museum NG.M.00844.
GW 483. Photo © Børre Høstland/National
Museum of Art, Architecture and Design.
Page 114: Rasmus Meyer's Collection, KODE
Art Museums and Composer Homes
RMS.M.259. GW 745. Photo © Dag Fosse/
KODE.
Page 116: Canica Art Collection, Oslo. GW 462.
Photo © Munch Museum.
Page 118: Munch Museum MM.M.00003.
GW 498. Photo © Munch Museum.
Page 119: Munch Museum MM.M.00008.
GW 832. Photo © Munch Museum.
Page 120: Munch Museum MM.M.00724.
GW 691. Photo © Munch Museum.
Page 121: Munch Museum MM.M.00272.
GW 568. Photo © Munch Museum.
Page 122: National Museum, NG.M.02237.
GW 495. Photo © Jacques Lathion/National
Museum of Art, Architecture and Design.
Page 125: Ateneum Art Museum, Helsinki.
GW 766. Photo © Ateneum.
Page 126, top: Munch Museum MM.T.01853.
Photo © Munch Museum.
Page 126, bottom: Munch Museum
MM.T.00534. Photo © Munch Museum.
Page 127: Munch Museum MM.M.00574.
GW 761. Photo © Munch Museum.
Page 130: Munch Museum MM.M.00004.
GW 768. Photo © Munch Museum.
Page 134: Munch Museum MM.M.00568.
GW 673. Photo © Munch Museum.
Page 135: Munch Museum MM.M.00393.
GW 1002. Photo © Munch Museum.
Page 138, top: Munch Museum MM.M.00803.
GW 1392. Photo © Munch Museum.

Page 138, bottom: Munch Museum
MM.M.00438. GW 807. Photo © Munch
Museum.

Page 139: Neue Nationalgalerie, Berlin.
GW 725. Photo © Munch Museum.

Page 140, top: Munch Museum MM.F.00055.

Page 140, bottom: Munch Museum
MM.F.00061.

Page 141, top: Munch Museum MM.F.00047.

Page 141, bottom: Munch Museum
MM.B.00-064.

Page 142: Unknown photographer. Munch
Museum archives MM.B.2559.

Page 143: Munch Museum MM.M.00543.
GW 688. Photo © Munch Museum.

Page 144: Munch Museum MM.M.00751.
GW 621. Photo © Munch Museum.

Page 145: Rasmus Meyer's Collection, KODE Art
Museums and Composer Homes RMS.M.262.
GW 825. Photo © Dag Fosse/KODE.

Page 147: Photo © National Museum of Art,
Architecture and Design.

Page 148: University of Oslo. GW 968.
Photo © University of Oslo/Munch
Museum.

Page 151: University of Oslo. GW 970.
Photo © University of Oslo/Munch
Museum.

Page 152: Photo © University of Oslo/Munch
Museum.

Page 154: Munch Museum MM.M.00318.
GW 1580. Photo © Munch Museum.

Page 157: Munch Museum MM G 395.
GW-gr.527. Photo © Munch Museum.

Page 158: National Museum NG.M.01865.
GW 1195. Photo © Jacques Lathion/
National Museum of Art, Architecture
and Design.

Page 162: Munch Museum MM.M.00365.
GW 1094. Photo © Munch Museum.

Page 163: Munch Museum MM.M.00371.
GW 1091. Photo © Munch Museum.

Page 164, top: Munch Museum MM.S.00001.
Photo © Munch Museum.

Page 164, bottom: Munch Museum
MM.M.00408.GW 1358. Photo © Munch
Museum.

Page 167: National Museum NG.M.01867.
GW 1296. Photo © Jacques Lathion/
National Museum of Art, Architecture
and Design.

Page 168: Unknown photographer. Munch
Museum archives MM.B.03318.

Page 170: Munch Museum.GW 1096.
Photo © Munch Museum

Page 171: Munch Museum MM.M.01031.
GW 1411. Photo © Munch Museum.

Page 172: Munch Museum MM.M.00051.
GW 1561. Photo © Munch Museum.

Page 175: Munch Museum MM.M.00884.
GW 344. Photo © Munch Museum.

Page 178, top: Munch Museum MM.T.01072.
Photo © Munch Museum.

Page 178, bottom: Munch Museum
RES.B.00124. Photo © Munch Museum.

Page 179: Munch Museum MM.M.00499.
GW1326. Photo © Munch Museum.

Page 180: Munch Museum MM.M.00713.
GW 1507. Photo © Munch Museum.

Page 181: Munch Museum MM.M.00752.
GW 1615. Photo © Munch Museum.

Page 183: Munch Museum MM.M.00407.
GW 1477. Photo © Munch Museum.

Page 184, top: Munch Museum MM.M.00061.
GW 1693. Photo © Munch Museum.

Page 184, bottom: Munch Museum
MM.M.00244. GW 1594. Photo © Munch
Museum.

Page 185: Munch Museum MM.M.00612.
GW 1334. Photo © Munch Museum.

Page 186: Munch Museum MM.M.00558.
GW 1690. Photo © Munch Museum.

Page 187: Munch Museum MM.M.00368.
GW 1465. Photo © Munch Museum.

Page 190: Munch Museum MM.M.00009.
GW 1451. Photo © Munch Museum.

Page 191: Munch Museum MM.M.00589.
GW 1462. Photo © Munch Museum.

Page 193: Munch Museum MM.M.00866.
GW 1718. Photo © Munch Museum.

Page 195: Munch Museum MM.M.00922.
GW 1840. Photo © Munch Museum.

Page 199: Munch Museum MM.M.00023.
GW 1764. Photo © Munch Museum.

Page 200: Munch Museum MM.M.01085.
GW 1781. Photo © Munch Museum.

Page 201: Photo: Teigens fotoatelier/DEXTRA
Photo, Norwegian Museum of Science
and Technology.

Page 203: Photo: Ragnvald Væring. © O. Væring
Eftf. Munch Museum archives M.B.1262.

INDEX

Page numbers in *italics* refer to illustrations

Frontispiece: Note dated 1889–90.

First published in the United Kingdom in 2020 by
Thames & Hudson Ltd, 181A High Holborn, London WC1V 7QX

www.thamesandhudson.com

First published in the United States of America in 2020 by
Thames & Hudson Inc., 500 Fifth Avenue, New York, New York 10110

www.thamesandhudsonusa.com

Where available, the quotations from Munch's writings cited in
this publication are the Munch Museum's official English translations
from eMunch.no, translated by Francesca M. Nichols. Quotation on
page 5 from Munch Museum MM.T.2748, sketchbook dated 1927–34.

British Library Cataloguing-in-Publication Data
A catalogue record for this book is available from the British Library

Library of Congress Control Number 2019949015

ISBN 978-0-500-29576-2

Printed and bound in China by C&C Offset Printing Co., Ltd.